# THE CHRISTMAS STORY
## IN MASTERPIECES

## INTRODUCED BY
## DAVID KOSSOFF

Collins, St. James's Place, London, 1977

**William Collins Sons & Co. Ltd.**
London · Glasgow · Sydney · Auckland
Toronto · Johannesburg.

**A Phaidon production.**

© 1977 Phaidon Press Ltd., Oxford.

ISBN: 0 00 216128 1

Printed in Italy by Amilcare Pizzi, SpA.

*Cover: the Adoration of the Magi, by
Gentile da Fabriano (c. 1370–1427).*

# Contents

# Introduction

# A Story of Simplicity and Power

My late father once said, "If you meet a man who believes the moon is made of green cheese, and it makes his life happier to believe it, you have no right to say a word." I was eighteen when my father made that statement. At eighteen, one knows about everything; one certainly knows that the moon is not green cheese. And at eighteen, one also knows that anyone who believes in a moon made of cheese must be a nut.

My father came from a little village in Russia and stayed a simple villager until he died, in late middle age, a poor tailor in London. He made many such statements, my father, and died when I was twenty-one, so I was never able to tell him that later I found all his gentle sayings to be not only right, in their way, but a solid bedrock for my life.

For he was not talking about cheese, the old man, he was talking about the comfort of faith, of belief. "Don't struggle," he said on another occasion, "go the way you are pushed." A village wisdom and a marvellous maxim. Absolute bedrock philosophy, when made in the sure knowledge that the pusher is God and the pushed should have faith that the pusher knows best.

Such certainty, such simplicity is a rarity nowadays. We live in remarkable times, supported, surrounded – and belaboured – by the media. Television grows and produces its own pundits by the hundred. Political leaders trained in sincerity talk to us, in full colour, in our own living rooms. We see unrest in other parts of the world as it happens. Yet the words of the pundits, the views of the leaders, the appearance of the rioters – along with their weapons, their dress, their phrases – all seem depressingly similar, no matter what their opinions or countries. A person could get confused by it all.

And yet. And yet. There are things which still come through the complicated, dirtying confusion of modern life quite unsullied. These things all have the same increasingly rare ingredient: simplicity, or new life.

For example: we respond to the young, the innocent, often surprising ourselves with the depth of our response. We are, in some odd and mysterious way, renewed. I like children. As I get older, and more jaded and cynical to match the world about me, I like younger children. I now like *babies* very much, who in my opinion reach their peak at three and then are adults, and it's downhill all the way. Babies who cannot yet talk are to me the most excellent company, full of silent wisdom and wide-eyed attention to my words.

The Christmas Story, too, is a simple thing. It, too, offers us new life. Humble parents, a baby, a stable, cattle in attendance – its very simplicity is moving. But that, of course, is only part of its tremendous appeal. It supplies many other basic human needs, and there is one in particular I want to talk about. For a very long time now I have been fascinated by what seems to be an extra sense given to mankind by the Almighty very early on, soon after Eden; an early modification. An extra instinct not much talked about, for it irritates the scientists, and ordinary people, even if they think about it at all, do not go too deeply into it – which could be part of that same remarkable instinct. The extra sense is the instinct to give thanks; to accept without

question that something bigger than we are is arranging things for us. "Oh *that*," you might say, and many people have said it to me, as though it is obvious, and proved by the countless sects and religions busy giving thanks all over the place. "Anybody," an American once said to me on an aeroplane, "can start a religion – and make it pay!" He wasn't particularly cynical. He was joking of course, but he had a point, because the urge to worship is universal.

Consider an absolutely primitive society. Jungle clearing. A tribe knowing nothing of clothes, or metal, or the wheel, perhaps not even of fire. A limited language of grunts and gestures. In that primeval society there will be no knowledge of the Scriptures, of God or Satan, of miracle or deliverance. Yet there will be in that society, in the social structure, in the family tradition, something that is bowed down to, prayed to, appeased, sacrificed to, kept happy. Positively, without doubt. A totem pole is no less a construction to the glory of a god than a Cathedral. It is the same inspiration, the same desire, the same extra sense.

For the millions upon millions who know it, the Christmas Story supplies many of the demands of that extra sense. So perhaps it is not surprising that the birth of a baby to poor parents in a stable has inspired so many artists across so many years – artists of every kind, from muralists with Emperors as patrons, to unknown carvers in softwood whose cribs and nativities show love in every gentle cut of the chisel. This book shows a carefully chosen selection of great work by great artists, but it is the merest scratch on the surface; the mass of art devoted to the first year or two of the baby Jesus is vast.

Much of the great Biblical art owes its existence to the patronage of the Church, or of wealthy dynasties or lay patrons who wanted to keep in with the Church – or chalk up credit for the eventual entry-form filling at the Heavenly Gate. But a lot of lesser painting of such subjects was done by artists who never enjoyed such patronage. Unknown men, who painted or carved wood or cut stone for their own private satisfaction, to be "discovered" long after, perhaps, by erudite experts and valuers, and labelled "of the school of," and sold to rockstar millionaires, tycoons or Arab oil-kings.

Private satisfaction is as important as the satisfaction of fulfilling a contract. A Medici may commission a Botticelli to paint a moment of Medici glory or a Medici profile or a Medici mistress. The result may give the artist one kind of satisfaction. But to produce an Annunciation or a Nativity is another thing. Little Medici self-glory in a birth in a stable – and for the artist a gentler fatigue, with love in it. It is no accident that often the best work of an artist is found in his Bible work.

But there is still more to that distant event than simplicity, a sense of divinity, an artistic inspiration. It is, after all, such a marvellous *story*. Think of the things that lend it colour. Shepherds on a quiet hillside who were told of the birth by a whole multitude of angels, in song. They were told also to go see for themselves and to spread the word. A great star appeared in the sky to welcome *that* baby; and learned astrologers working independently, in three different countries far away, found matching signs and omens that set them journeying to meet the new baby, bearing priceless gifts. Great Herod himself welcomed them, so prince-like and important were they – and their talk of the birth in Bethlehem of "a babe who would be a King" scared the sick old ruler. For years he had shed blood to keep his throne, and trusted nobody. He was ill, and half-mad. He went to great trouble, did Herod, to find and kill that baby, but failed. The child was spirited away to safety – and within the year Herod was dead.

Yes, a marvellous story. As a writer and performer of Bible stories, I should know (although I also know full well that the major attraction of my work is that I remind people of half-remembered things. No-one writes Bible stories; one re-writes them). The first New Testament story I ever wrote was called *The Three Donkeys*; it is obvious and corny and I love it and it is part of my one-man show. It is not in my

show because I love it and wrote it, but because I discovered it to be hypnotic to an audience. I am very choosey in my material and the little story stays in because it never misses. It tells of three donkeys in Heaven. All came from the same part of the world; all lived at roughly the same time. So they tell each other their stories. The first tells of being bought by a carpenter of Nazareth . . . well, I said corny (you can read it for yourself; it is reprinted below). Donkeys in Heaven indeed. Talking to each other, yet. (If you are really crazy to know what the other two say, one tells of a boy in the Temple astonishing the Elders with his knowledge – and the third tells of a young preacher who was crucified.)

Now I tell you this not to sell the little tale, but to show you that *this* lovely book is no more than the story of the First Donkey, if at a rather more elevated level. Certainly our donkey does not speak of the announcement to Mary of her no-man-involved motherhood, the Annunciation, for he wasn't bought by the carpenter till later, but the rest is in his story – and in the pictures that follow these words. The journey to Bethlehem, the Stable, the Shepherds, the Coming of the Wise Men, the Flight to Egypt. But look now at the "illustrators" of the story. El Greco, Rembrandt, Raphael, Bellini, Donatello, Bruegel, Holbein, Botticelli, great Leonardo. Mighty talents, working at the very top of their bent, lit up, inspired. Who could ever deny the story's fascination?

So the three donkeys stay in my show, never failing me. And if, here and there in the audience, in the rapt dark silence, a tear falls, a pent-up sigh is released, it doesn't matter too much, for nobody can see and the person in the next seat might well be in the same state.

And if in these TV-orientated times, when we are up to here in wrong priorities and violence and unrest and tension, we can be caught up and made to weep a little by an ancient story known to everyone, it is no bad thing. Slightly embarrassing it may be; it is also an astonishment and a sort of marvel. Like everybody I know, I am appalled and irritated by the colossal commercialization of Christmas each year. I hate it. But when the presents have been bought and secretly wrapped and hidden, and the house made festive and gay and the Eve has come, something else comes too. A peacefulness, a pause, a reminder of simplicity. There is a feeling in the air, can it be love for my neighbour? Goodwill to all men? Has the heart opened a touch? Was that an angel on a hill? Is that star brighter than the others suddenly?

How stubbornly undiluted is the Christmas Story! I have in these last few years

## The First Donkey's Story

When I tell people, as I now tell you, that now comes a story about three donkeys in Heaven, it has some odd effects. One of the oddest is that many people who have always said they don't believe in Heaven are rather offended at the thought that donkeys should be allowed in. Very illogical. If Heaven is for people who are rather nice, why not for donkeys, who in the main are nicer than people? Most animals are, don't you agree?

Anyway. Three donkeys, spending an afternoon together in Heaven. They'd all been there a very long time. Centuries. By accident they'd discovered that they'd all come from the same part of the world, and had arrived in Heaven, give or take a few years, at the same time. Very pleasant and interesting for them. They all looked rather alike. Well, donkeys do. They were lying in the shade. One of them was telling his story, and the other two were very interested. Are you?

The first donkey said, "I had a number of masters, but I remember one better than I do the others. Not because of *him* so much – although he was a very kind and gentle man – but more because of one or two strange things that happened during the time I worked for him. He was a carpenter, and he worked and lived in Nazareth. Not a rich man. Not many possessions. I don't think he would have bought me but there'd been a Roman order that made it necessary for him to go to Bethlehem. A census was being taken. Anyway he bought me so that my mistress could ride there. You see, she was going to have a baby – and pretty soon too. And she had to go to Bethlehem as well; it was a Roman order and nobody ever argued with a Roman order. So we went. Took a long time. I trod as soft as I could.

"When we got there it was late at night and the town was bursting with people. The inns and rooming houses were packed. No room anywhere. The last inn-keeper my master asked at least *tried* to help. He said his stable was dry and warm and we could spend the night there. I was a bit worried for my mistress, in her condition. I

seen many Nativity playlets done in infant or junior schools, with casts of many colours and nationalities. The magic works every time, without fail. It compels our attention. There are no distractions.

Not that there is a lack of them in the Bible. At roughly the same time, Mary's aunt, Elisabeth, in old age, like Abraham's Sarah, was also given a baby by God. Zacharias, her Temple-servant husband, was visited at work by the Angel Gabriel himself and given the news. When the old man expressed some doubt the angel thought it best to make him dumb till the christening. Then the old man, in full voice, yelled, "John will be his name." Great man, that baby turned out to be: John the Baptist. Good solid stuff, one would think, for artists. Not at all. It is difficult to find paintings of that lovely, parallel happening.

Certainly, the end of the life, the Crucifixion and the Resurrection, has over the centuries attracted artists beyond number, but what of the miracles of the ministry period? Marvellous moments, and lots of them. Covered far less fully. No, the Christmas Story is the one, and we succumb to it, we go the way we are pushed, without struggle, for it offers simplicity in unsimple times, it gives back to us a little of the beauty of childhood. We suspend disbelief, we accept without question, we spurn those who insist too loudly that the moon can *not* be made of cheese.

"Don't ask too many questions," my old man said once to one of my know-it-all (like me) friends, "You may finish up with just a lot of answers." The Christmas Story stops the questions; we are caught up, made willing captives. And we are the better for it.

I know *I* am. I am a Jew, but also a storyteller. Perhaps storyteller first and Jew second, and thus I can respond more fully to the marvellous simplicity of the Christmas Story; although they tell me it is a Christian matter, not Jewish. Really? A Jewish carpenter and Jewish girl, both of distinguished Jewish lineage, raise a baby who is circumcised according to Jewish law and later taken for priestly blessing in the Great Temple of the Jews in Jerusalem. My father, bless his sweet memory, would have chuckled. But let us not be argumentative, because, as the angel said, the story is for all mankind.

I have in a small way experienced its universality. Let me tell you how. Ten years ago, I published a book of Old Testament stories. It was a success. My publishers, wise in the ways of booksellers, gave me rich lunches and demanded another book, similar. "*New* Testament now," they said. "The obvious sequel." It was not easy for

mean I've slept in stables all my life but she was rather a refined, well brought up, quiet sort of person. My master settled her down as comfortably as he could. He loaded the largest manger with hay and straw from all the others and she lay on that.

"Well, I must have dozed off. The thing that woke me up was the sound of men's voices. At first I thought it was the Romans but then I saw it was a crowd of shepherds. They were excited. Some were praying. On the manger lay my mistress and in her arms her new-born baby. As far as I could make out, these shepherds, in the middle of the night, had been told by a whole *army* of angels that my mistress's baby was something very special. They were told where to come and see for themselves, and then to go and spread the word that this baby, born in a stable shared by me and two other donkeys and a cow, was going to change the world!

"Well, people *did* get excited, but not for long. Mind you, one good thing – one or two people helped my master find somewhere to live in Bethlehem till my mistress felt stronger. They lived very quietly. No miracles. You'd have thought that exciting night had never happened. I'd nearly forgotten it. Well about six months after that night we had another big night. Not shepherds this time. No, not shepherds – more like princes! There were three of them, all from different places far away. Servants by the dozen, camels, a fine old to-do. They blocked the street! They also spoke of angels, and a great star in the sky, which had guided them, and special signs which, because they were all three of them very wise men, they knew had meant that our baby was special.

"'A saviour,' they said. 'A king,' they said. 'Greater by far than King Herod,' they said. Well, when I heard that I knew there'd be trouble. I was right. The next morning the wise men had gone. And by midday so were we. Seems God told my master to take the special baby and the special baby's mother and the special baby's donkey and get far away *fast* because King Herod was cross. We went down to Egypt I remember."

The first donkey looked at the other two. "There must have been something *very* special about our baby," he said, "though I must say in the six years I was with the family *I* never noticed anything."

me, for I had to find a format that would let me feel as relaxed in the New as I did in the Old. I had to overcome the inhibition that all Jews have about the "other" book. The Jews have kept their ancient religion pure by being very delicate-footed about other beliefs. I was willing – and interested. But I couldn't get started. It was coming out wrong. Then my *Three Donkeys*, written some time before, saved me. They had *been* there, they had *seen*, they had witnessed. The answer! Multiply up the donkeys and make them people and take down their statements! And *The Book of Witnesses* was born.

Good; stay with me; many people have asked me, in many different ways, from the gently probing to the blunt and loud, whether I am now changed in some way by having written about Jesus. Do I accept him? Do I recognize his divinity? Do I see him as the Messiah? And so on. I, not a very deeply observing Jew, but happy enough with my religious label (one should have *some* kind of label, or the kids get confused) could never see the point of the question, which was always asked by genuinely interested people. To evade or parry the question I would point out that I am a storyteller only, a professional entertainer, a teller of tales, an upholder of an ancient craft. I would remind my questioners that I wear another hat also; that of actor, playing many roles in my time – and quite unaffected and unchanged by any of them! Or I would make a joke (a sad failing). "If I had written a successful book about primitive jungle tribes," I would ask, "would you be asking me if I am now a cannibal?"

Here now is a funny thing. *The Witnesses* always prompts the questions I've just listed; *The Donkeys* never. A puzzlement. Can it be that their simple words (donkeys don't have a very big vocabulary) and vivid pictures make pictures in *our* minds that are independent of formal beliefs?    Perhaps it is easier to accept the words of elderly donkeys than of ass-like elders. Especially if the donkeys tell *that* story.

We grow up too soon, and the magic goes. Our wide-eyed acceptance of "stories" is too soon replaced by a determination not to be "taken in" by *anything*. Who needs imagination with a colour television? How sad it is. I have a conviction that grown-ups *want* to suspend disbelief; to be made wide-eyed; to accept; to hang up a stocking. And I am right. I know about audiences. I have to; it is part of my trade as solo performer. And I know the different kinds of quiet. It cannot be described, this difference. And I know, good friends, when people are accepting, letting go, slowing down, *believing*, like children.

So come, children, look at a picture book. Look carefully and long at each picture. Take your time, for there is a sort of trick to it. After a time you get past the brushwork, the composition, the marvellous skills of flesh tints and textures and detail, the use of colour and light. And a remarkable thing happens. The gentle simplicity of the subject emerges. The high formality of one period or the loose freedom of another make no difference. The message of the Story of Christmas is a clear and simple one and the clarity and simplicity come through. Look and enjoy; and be patient, for it's worth it.

**David Kossoff**

The quotations on the following pages are taken from the Gospels according to St. Matthew, Chapter 2, and St. Luke, Chapters 1 and 2, in the Authorized Version.

*Complete with 17th-century instruments – recorder, lute, virginal and harp – an angel ensemble heralds the descent of Gabriel and the Holy Spirit to Mary. A dove was the usual symbol of the Spirit, from St. Mark's reference to its descent "like a Dove" upon Christ at his baptism.*

# I : The Annunciation

The angel Gabriel was sent from God unto a city of Galilee, named Nazareth,

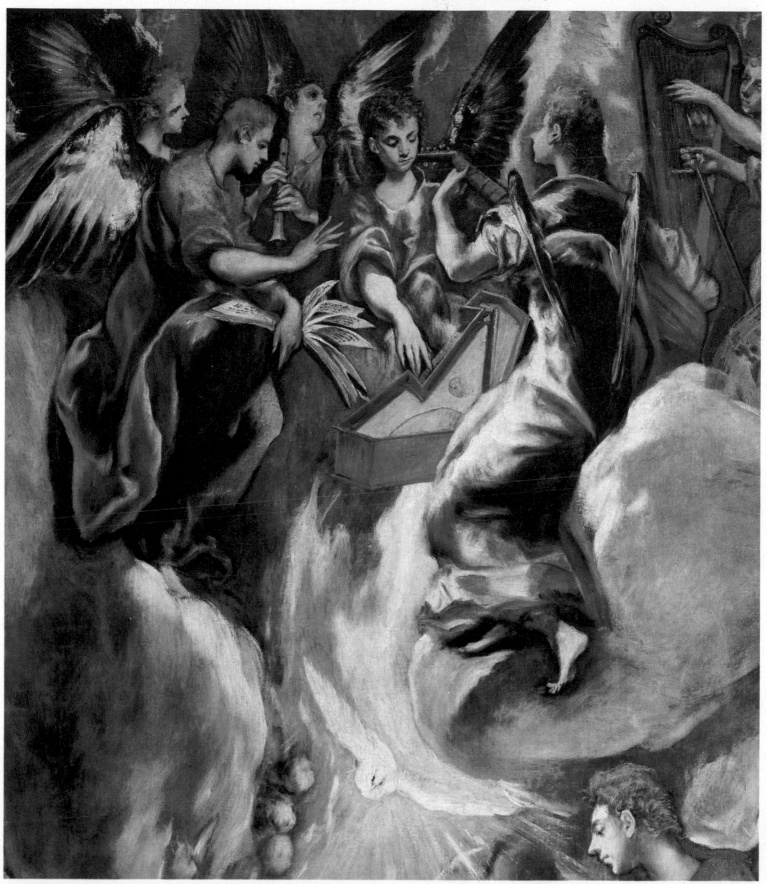

**1.** ANGELS FROM *THE ANNUNCIATION*, BY EL GRECO. PAINTED 1596–1600. DETAIL OF PLATE 5.

To a virgin espoused to a man whose name was Joseph, of the house of David; and the virgin's name was Mary.

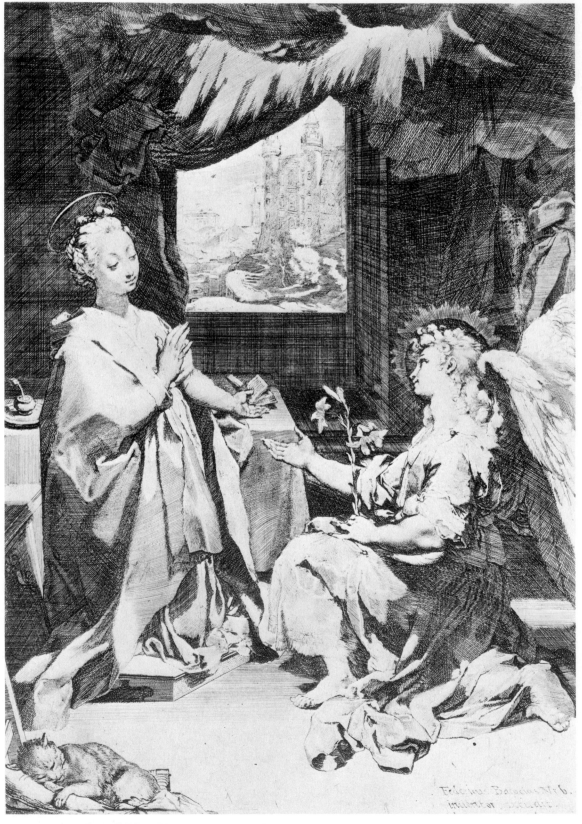

2. *THE ANNUNCIATION*, BY FREDERICO BAROCCI. ABOUT 1585.

*Gabriel kneels in reverence and humility before the Saviour incarnate in the Virgin. He bears a lily, the symbol of her purity. Note the detail of the cat asleep on the chair in the left foreground.*

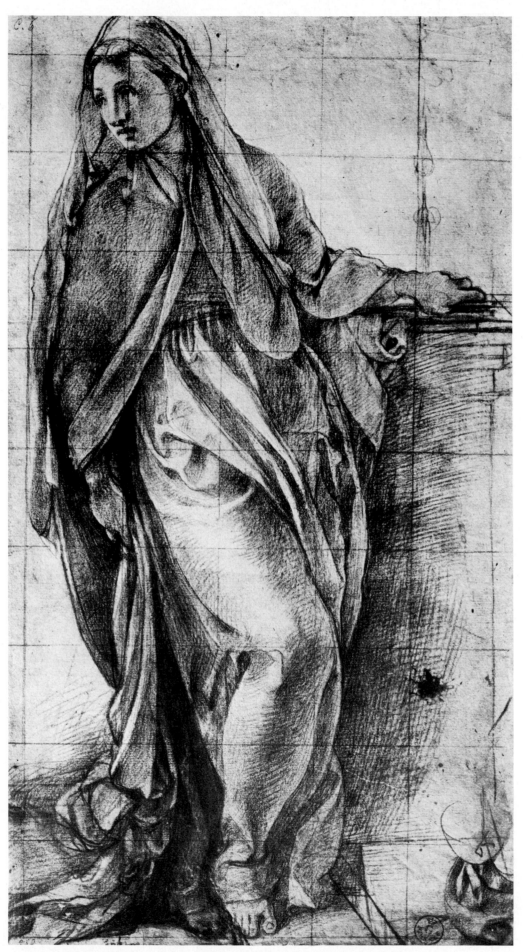

In this sketch done for a mural, Mary –
barefoot to symbolize her humility – turns
in surprise at the sudden presence of the
angel. The squares helped with the
transfer of the design to a wall.

**3.** *THE VIRGIN MARY OF THE ANNUNCIATION, BY PONTORMO. 1520'S (?).*

And the angel came in unto her, and said, Hail, thou that art highly favoured, the Lord is with thee: blessed art thou among women. And when she saw him, she was troubled at his saying, and cast in her mind what manner of salutation this should be. And the angel said unto her, Fear not, Mary: for thou hast found favour with God.

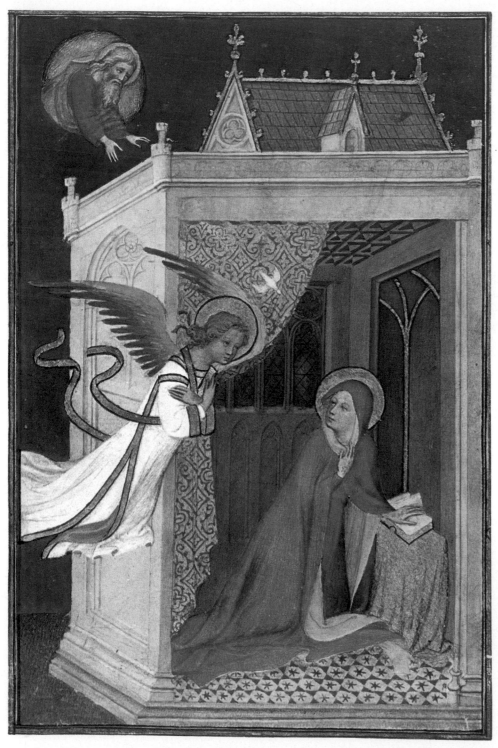

Mary, portrayed here in a medieval chapel in the traditional dark blue mantle, is visited by Gabriel, as intermediary between God (top left) and mankind. Within the chapel – one wall of which has been removed to create a stage-like interior – the perspective seems "wrong". But it would not have seemed so at the time, for the laws of perspective were not fully formulated for another fifty years.

4. *THE ANNUNCIATION*, BY JACQUEMART DE HESDIN. PROBABLY AROUND 1400.

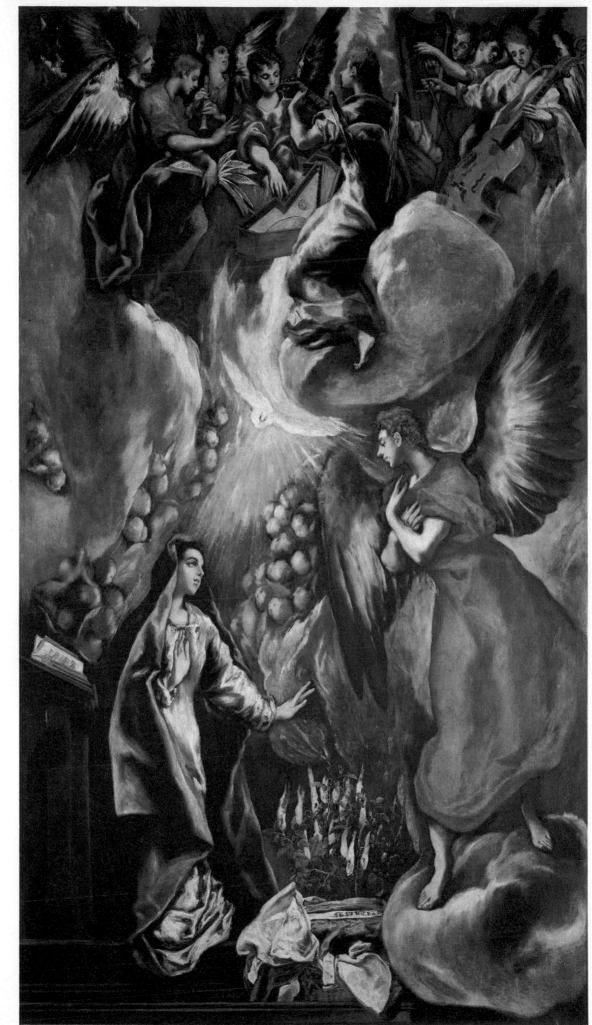

Mary, interrupted in her reading – another of the traditions associated with Biblical art – looks round to hear Gabriel's message, her eyes upturned, her face impassive in a pose seen as representing a state of blissful purity.

**5.** *THE ANNUNCIATION,* BY EL GRECO. PAINTED 1596–1600.

And, behold, thou shalt conceive in thy womb,
and bring forth a son, and shalt call his name
JESUS. He shall be great, and shall be called
the Son of the Highest: and the Lord God shall give
unto him the throne of his father David: And he shall
reign over the house of Jacob for ever; and of his
kingdom there shall be no end. Then said Mary unto
the angel, How shall this be, seeing I know not a man?

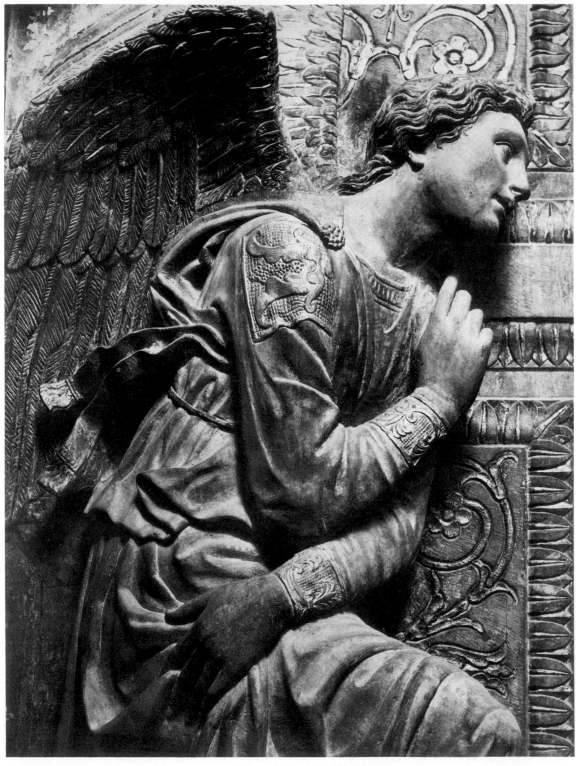

*The solidity of Donatello's limestone
Gabriel acts as a reminder that, in
medieval theology, the archangels were –
along with angels – the only two of the
nine heavenly "choirs" to adopt material
form in their role as intermediaries
between God and the created universe.*

**6.** THE ANGEL, DETAIL OF *THE ANNUNCIATION*, BY DONATELLO. ABOUT 1428–33.

nd the angel answered and said unto her, The Holy Ghost shall come upon thee, and the power of the Highest shall overshadow thee: therefore also that holy thing which shall be born of thee shall be called the Son of God. And, behold, thy cousin Elisabeth, she hath also conceived a son in her old age: and this is the sixth month with her, who was called barren. For with God nothing shall be impossible.

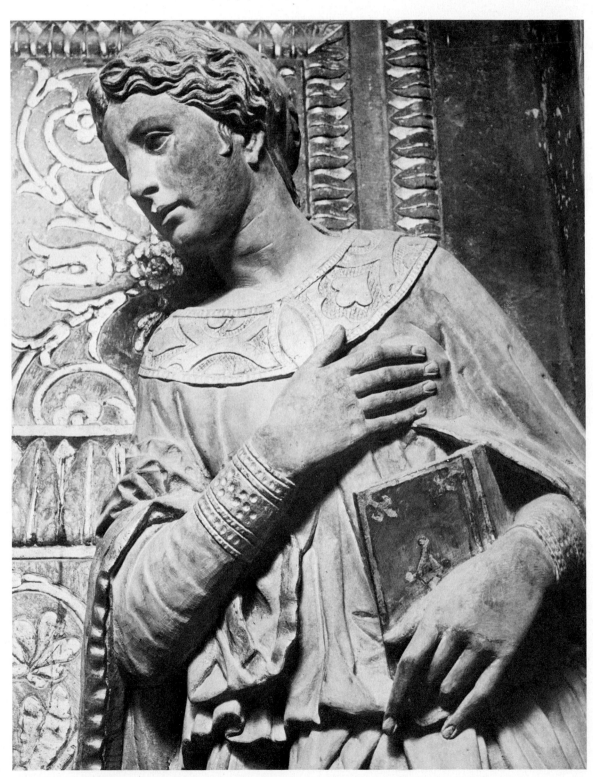

*Donatello has here posed the Virgin in the act of leaving, her garment folded as she turns back to see the archangel Gabriel. The capture of this subtle, theatrical gesture – the only time it was used in Renaissance art – represents a high point of achievement in sculpture.*

**7.** THE VIRGIN, DETAIL OF *THE ANNUNCIATION* BY DONATELLO. ABOUT 1428–33.

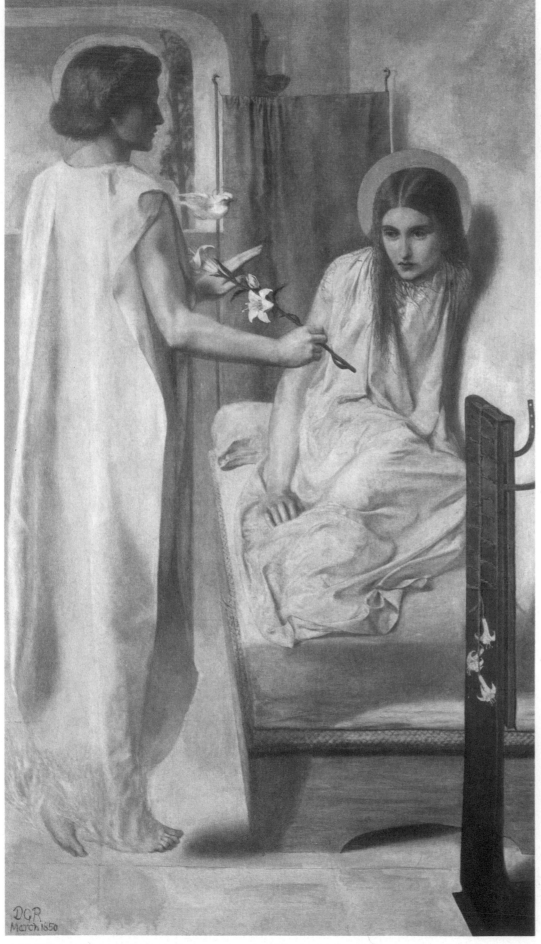

8. 'ECCE ANCILLA DOMINI', BY DANTE GABRIEL ROSSETTI. 1850.

And Mary said, Behold the handmaid of the Lord; be it unto me according to thy word. And the angel departed from her. And Mary arose in those days, and went into the hill country with haste, into a city of Juda; And entered into the house of Zacharias, and saluted Elisabeth. And it came to pass, that, when Elisabeth heard the salutation of Mary, the babe leaped in her womb; and Elisabeth was filled with the Holy Ghost: And she spake with a loud voice, and said, Blessed art thou among women, and blessed is the fruit of thy womb.

◀ *In this mid-19th-century Annunciation scene, Mary recoils in amazement at Gabriel's appearance. This natural reaction by a simple, innocent girl seems thoroughly modern; but it contrasts with the many traditional elements in the picture – the lily of virginal purity, the blues, reds and golds typical of much early religious painting. Such devices recall the simplicity of early art which Rossetti and other Pre-Raphaelite painters sought to recapture in their works.*

▶ *Mary (centre) greets the elderly Elisabeth, who is, like Mary, miraculously pregnant. As in Rossetti's painting, the figures are made to stand out powerfully by the use of exaggerated, steeply rising perspective.*

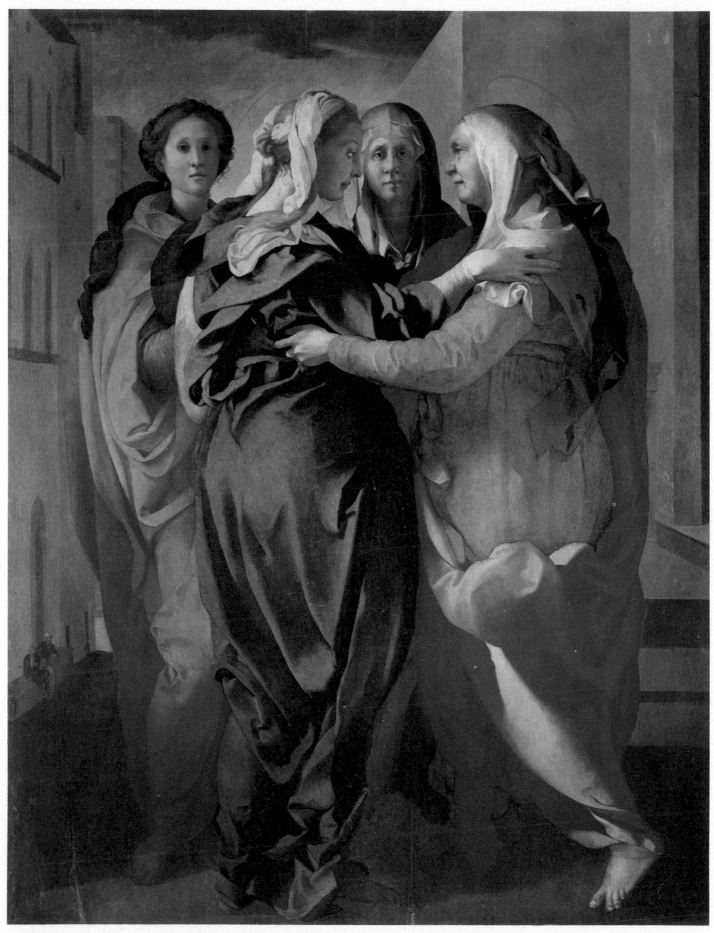

**9.** *THE VISITATION,* BY PONTORMO. ABOUT 1528–30.

And whence is this to me, that the mother of my Lord should come to me? For, lo, as soon as the voice of thy salutation sounded in mine ears, the babe leaped in my womb for joy.

▼ *With these four sketches, Sir Peter Paul Rubens was experimenting for an oil painting. They show the arrival of Mary at Elisabeth's house (top), Mary with Joseph and Elisabeth (left), Elisabeth kneeling (bottom) and a rapid sketch of the two women together (right).*

▶ *Michelangelo's Mary is shown in a diaphanous costume swinging round to confront Gabriel, who must be imagined to be kneeling outside the picture. As with many of Michelangelo's women, Mary's face is more that of a young man than of an innocent girl.*

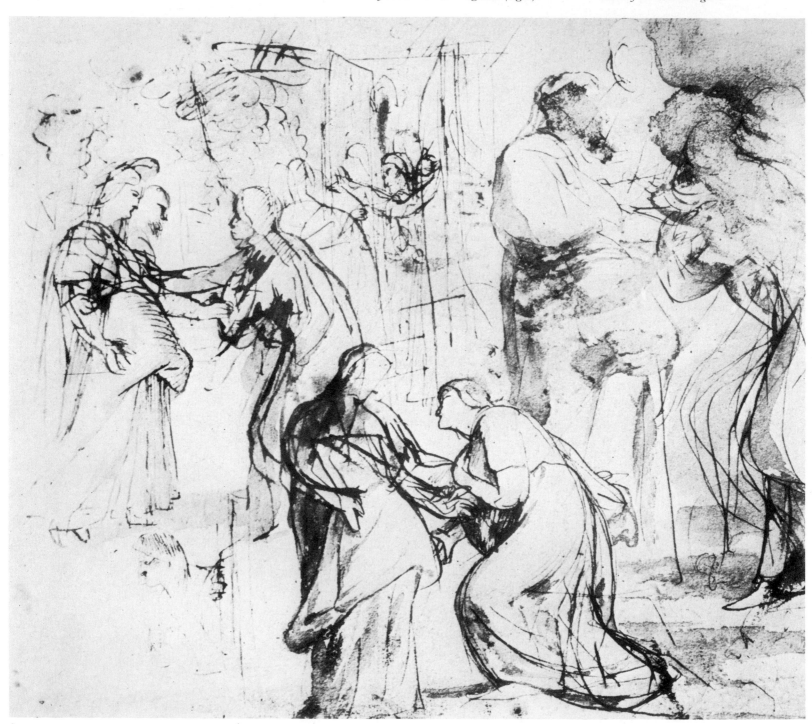

**10.** STUDIES FOR *THE VISITATION* (DETAIL), BY SIR PETER PAUL RUBENS. ABOUT 1612–13.

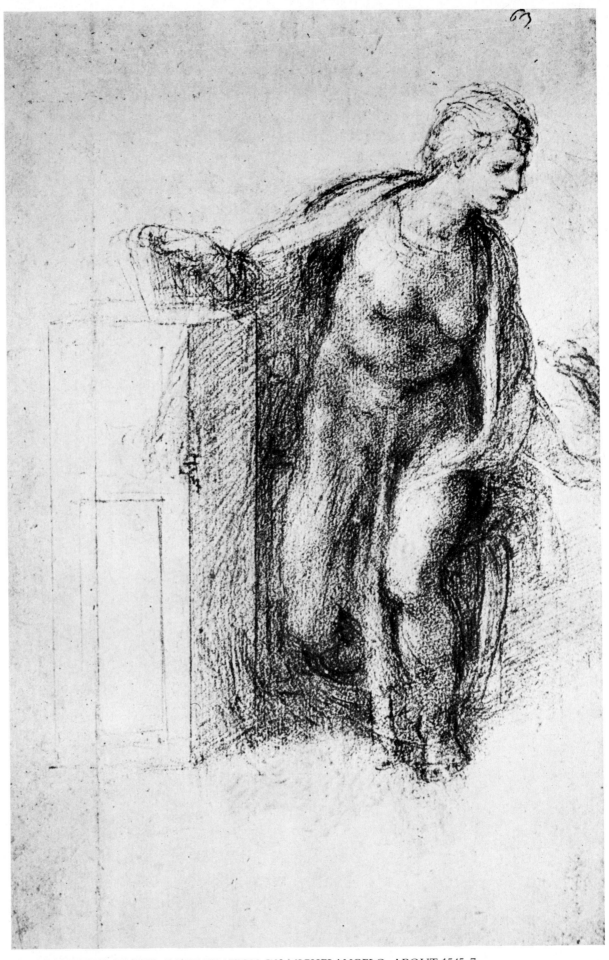

**11.** *THE VIRGIN OF THE ANNUNCIATION*, BY MICHELANGELO. ABOUT 1545–7.

## 2: Unto Bethlehem

And it came to pass in those days, that there went out a decree from Caesar Augustus, that all the world should be taxed. (And this taxing was first made when Cyrenius was governor of Syria.) And all the world went to be taxed, every one into his own city.

And Joseph also went up from Galilee, out of the city of Nazareth, into Judaea, unto the city of David, which is called Bethlehem; (because he was of the house and lineage of David:) To be taxed with Mary his espoused wife, being great with child.

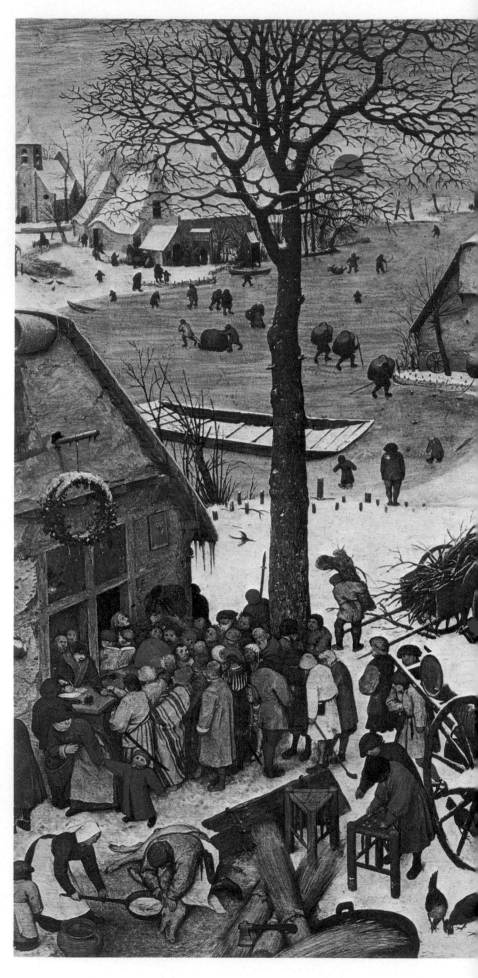

*For this rarely chosen subject – the Holy Family's arrival in Bethlehem to register for taxation on orders from Rome – Bruegel portrayed his own Flanders. This must have given the picture a poignant immediacy for his fellow-countrymen, for the political parallels between Palestine and his own country – then under Spanish rule – would surely have been clear. It is a scene of startling realism. Hens peck for food in the snow. A pig is butchered. Children snowball. And all are unaware of an insignificant carpenter, his saw over his shoulder, who accompanies his pregnant wife. An ox and an ass – the traditional animals of the Nativity – offer the only clues to their identity.*

**12.** *THE NUMBERING AT BETHLEHEM (DETAIL)* BY PIETER BRUEGEL THE ELDER. 1566.

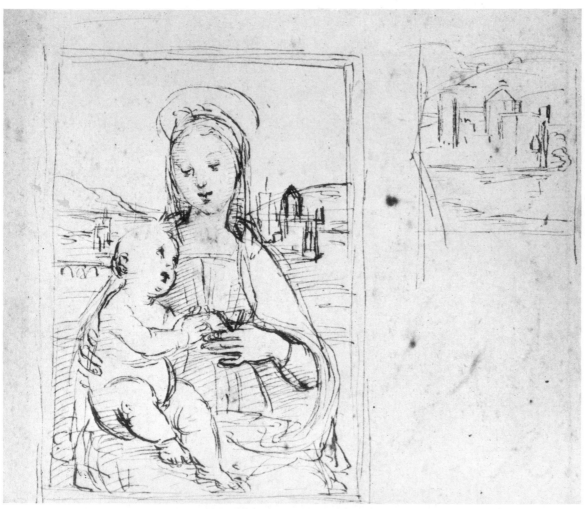

This little known, loosely drawn view of mother and child exemplifies uncounted works in which Mary represents loving motherhood. Here, Raphael has sought to symbolize the relationship by the way the pair look at each other. He has set the scene in a frame (not a window) against an idealized landscape, which is repeated at top right.

**13.** *STUDIES FOR A VIRGIN AND CHILD*, BY RAPHAEL. ABOUT 1502–4.

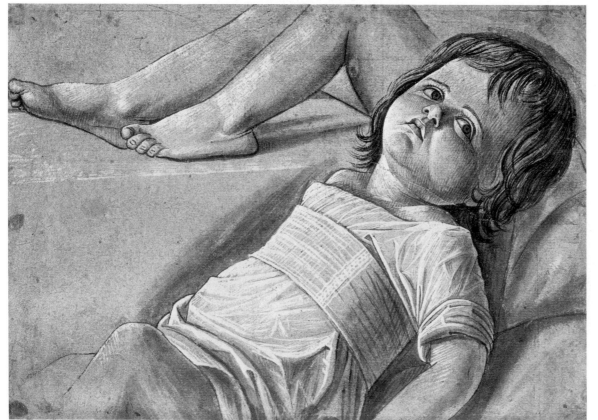

In this version of the Christ Child, the baby is dressed in a loose, latter-day version of swathing bands. The child is clearly not new-born. Indeed, the problems of portraying very new babies were seldom tackled, perhaps because of their looks, but perhaps also because of the difference in scale between mother and child.

**14.** *STUDY FOR A FIGURE OF THE INFANT CHRIST*, ASCRIBED TO BELLINI. 1480–90 (?).

And so it was, that, while they were there, the days were accomplished that she should be delivered. And she brought forth her first-born son, and wrapped him in swaddling clothes, and laid him in a manger; because there was no room for them in the inn.

*The Holy Family rests, portrayed in the most delicate yet down-to-earth terms. With the chimney-breast sloping down behind them, and Joseph lying flat out on the floor, they might be an ordinary Dutch family at peace in their own home, but for the faintly-drawn angels hovering over the sleeping Christ Child.*

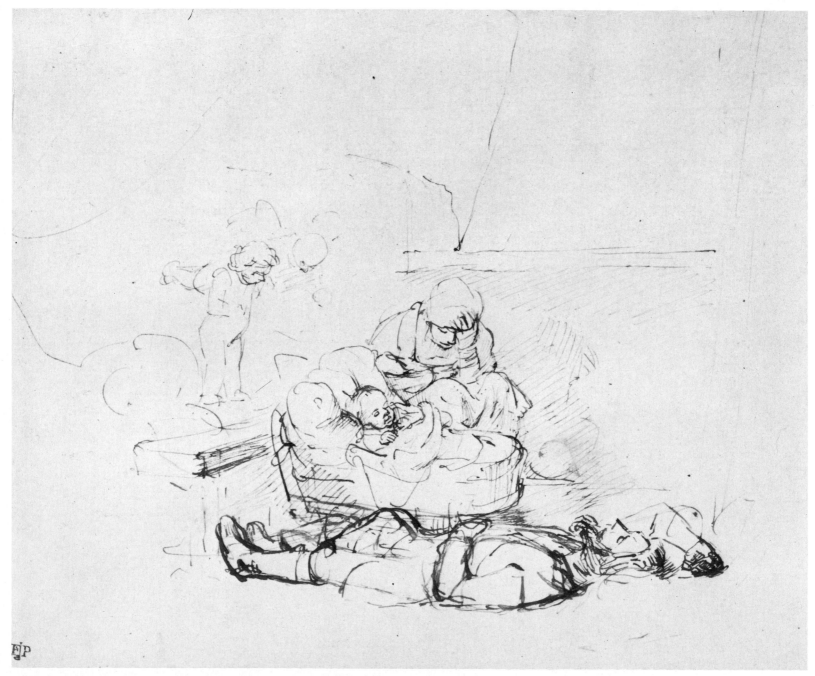

**15.** *THE HOLY FAMILY ASLEEP WITH ANGELS,* BY REMBRANDT. ABOUT 1645.

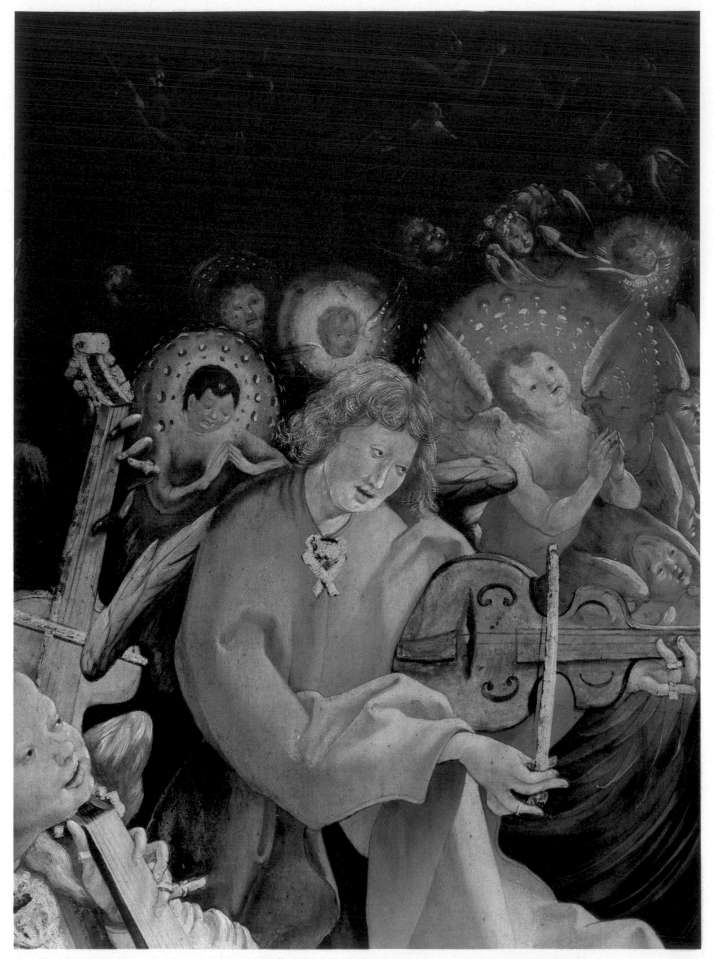

**16.** *ANGELS MAKING MUSIC*, BY MATHIS GRÜNEWALD. ABOUT 1513–16. DETAIL OF PLATE 35.

And there were in the same country shepherds abiding in the field, keeping watch over their flock by night. And, lo, the angel of the Lord came upon them, and the glory of the Lord shone round about them: and they were sore afraid.

And the angel said unto them, Fear not: for, behold, I bring you good tidings of great joy, which shall be to all people. For unto you is born this day in the city of David a Saviour, which is Christ the Lord. And this shall be a sign unto you; Ye shall find the babe wrapped in swaddling clothes, lying in a manger.

And suddenly there was with the angel a multitude of the heavenly host praising God, and saying, Glory to God in the highest, and on earth peace, good will toward men.

And it came to pass, as the angels were gone away from them into heaven, the shepherds said one to another, Let us now go even unto Bethlehem. . . .

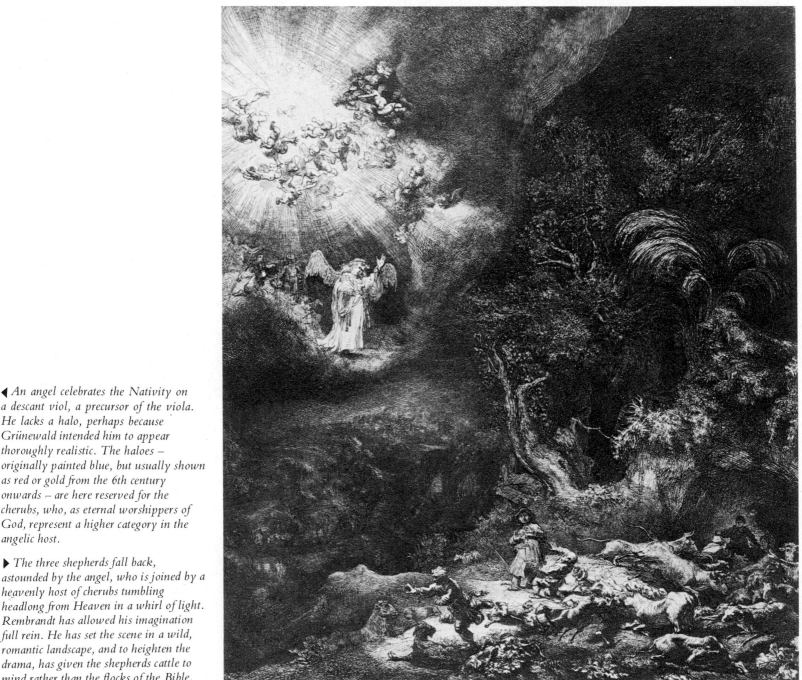

◀ *An angel celebrates the Nativity on a descant viol, a precursor of the viola. He lacks a halo, perhaps because Grünewald intended him to appear thoroughly realistic. The haloes – originally painted blue, but usually shown as red or gold from the 6th century onwards – are here reserved for the cherubs, who, as eternal worshippers of God, represent a higher category in the angelic host.*

▶ *The three shepherds fall back, astounded by the angel, who is joined by a heavenly host of cherubs tumbling headlong from Heaven in a whirl of light. Rembrandt has allowed his imagination full rein. He has set the scene in a wild, romantic landscape, and to heighten the drama, has given the shepherds cattle to mind rather than the flocks of the Bible.*

**17.** *THE ANGEL APPEARING TO THE SHEPHERDS* (DETAIL), BY REMBRANDT, 1634.

# And see this thing which is come to pass, which the Lord hath made known unto us.

▼ *The supreme sense of calm in Piero's picture, with its intensely-lit Italian setting, derives initially from the serenity of Mary and from the intimate touch of a helpless, dependent Jesus placed upon her cloak. The sense of peace is enhanced by the harmony of blues and by the geometrical structure – the triangle of Mother and Child, for instance, and the rectangle of the angel choir.*

▶ *This is a very unusual Nativity. All the religious paraphernalia that usually identified religious characters has been excluded. There is no indication in the candle-lit scene that the Mother and Child are Holy Persons. The evidence lies solely in the painting's stunning purity and simplicity, and the possibility that it was commissioned for a local convent in Lorraine, where La Tour lived.*

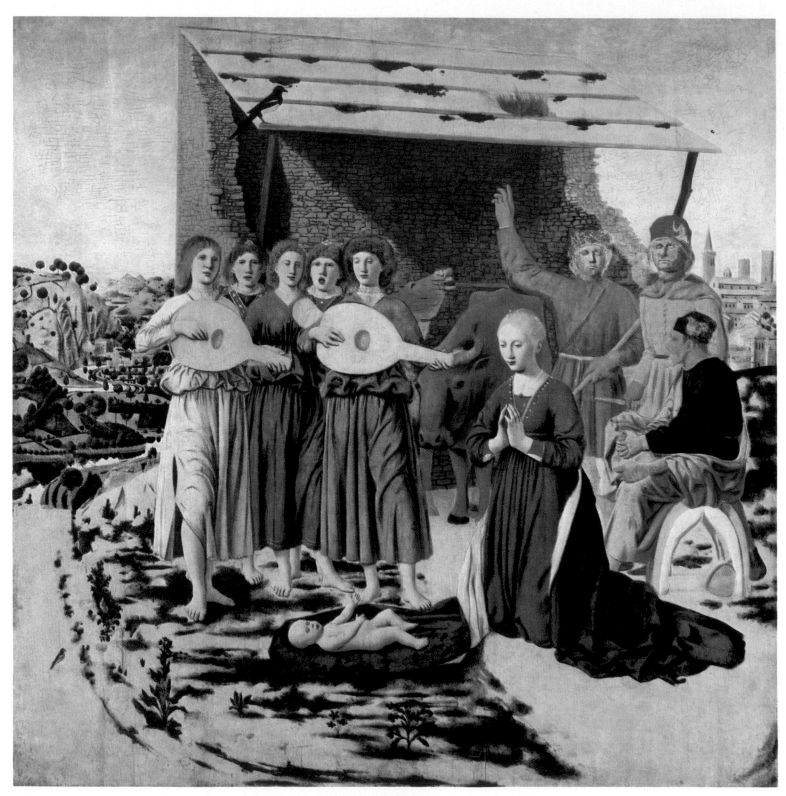

**18.** *THE NATIVITY*, BY PIERO DELLA FRANCESCA. PERHAPS ABOUT 1470–75.

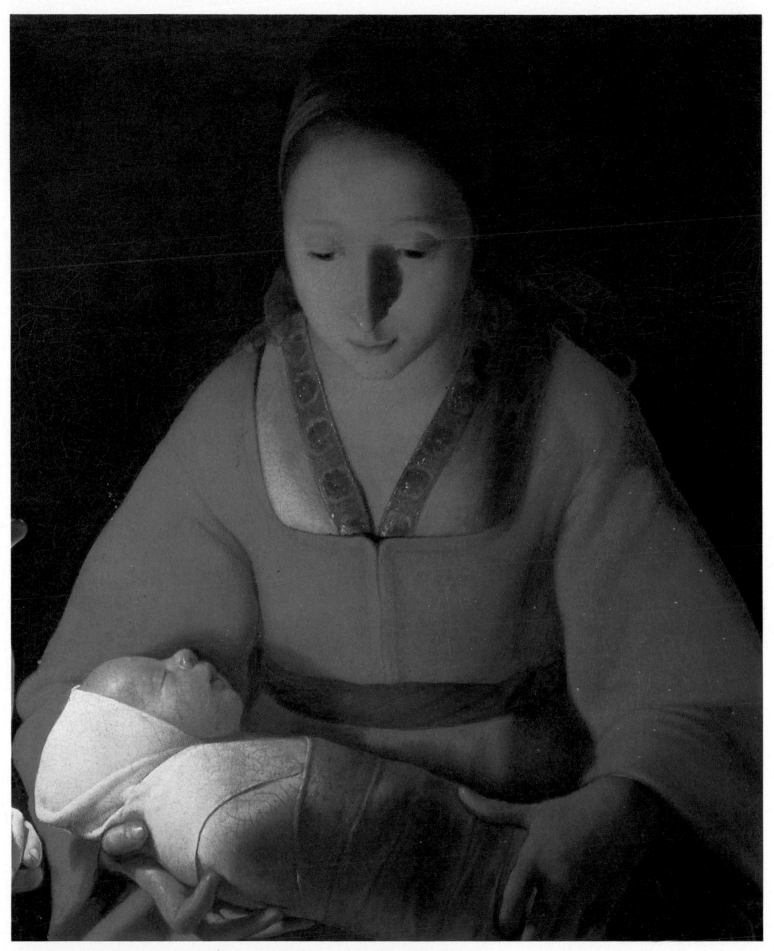

**19.** *THE NEW-BORN CHILD* (DETAIL), BY GEORGES DE LA TOUR. ABOUT 1646–8.

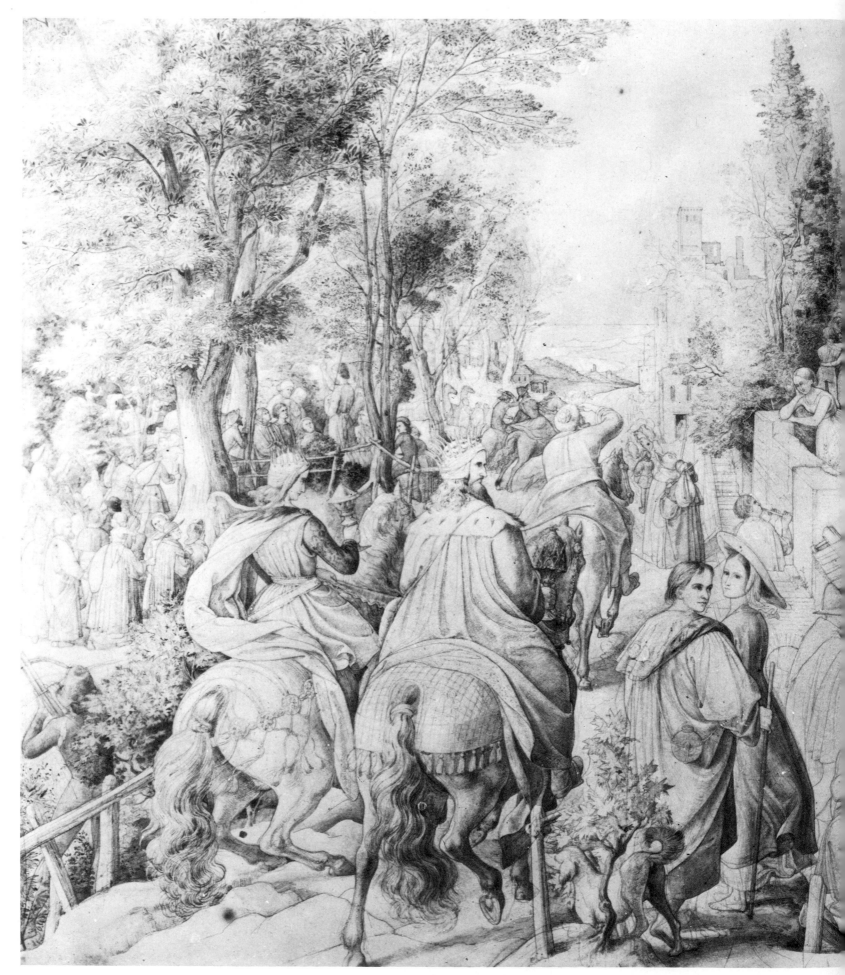

**20.** *THE PROCESSION OF THE THREE MAGI*, BY JULIUS SCHNORR VON CAROLSFELD. 1819.

# 3 : The Coming of the Wise Men

**N**ow when Jesus was born in Bethlehem of Judaea in the days of Herod the king, behold, there came wise men from the east to Jerusalem, Saying, Where is he that is born King of the Jews? for we have seen his star in the east, and are come to worship him.

*The Three Kings make their way towards Bethlehem in a 19th-century version of a medieval allegory (the details of which are explained in the Notes that follow the plates). The wise men seek salvation, symbolized by the star. In scenes that foreshadow the later life of Christ, John the Baptist preaches (left, middleground), the Foolish Virgins celebrate (right, background) and the Wise Virgins perform acts of charity (right, foreground).*

*In one of the three cavalcades that decorate the chapel of his Florentine patrons, the Medici family, Gozzoli shows a young – even angelic – King leading a courtly Renaissance pageant through a fanciful rocky landscape. Four of the Medici are portrayed riding (left).*

**W**hen Herod the king had heard these things, he was troubled, and all Jerusalem with him. And when he had gathered all the chief priests and scribes of the people together, he demanded of them where Christ should be born. And they said unto him, In Bethlehem of Judaea: for thus it is written

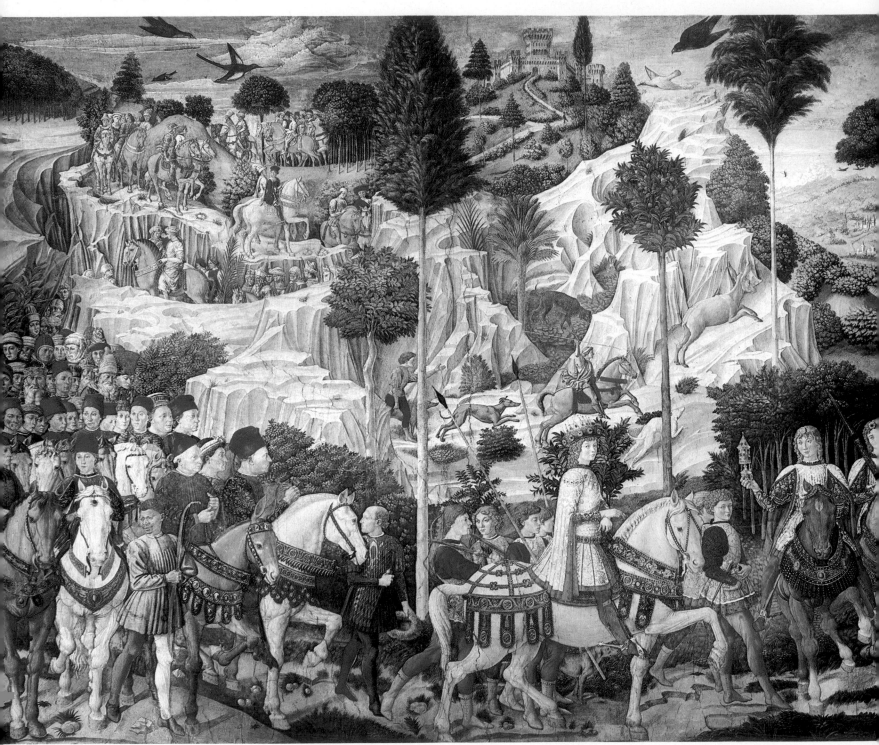

**21.** *THE JOURNEY OF THE MAGI* (DETAIL), BY BENOZZO GOZZOLI. 1459–61.

by the prophet, And thou Bethlehem, in the land of Juda, art not the least among the princes of Juda, for out of thee shall come a Governor, that shall rule my people Israel.

Then Herod, when he had privily called the wise men, inquired of them diligently what time the star appeared. And he sent them to Bethlehem, and said, Go and search diligently for the young child; and when ye have found him, bring me word again, that I may come and worship him also.

*The Three Magi, or wise men, here shown twice – once observing the star and again on their journey – had, by the time of this work, long since acquired kingly attributes. They had also acquired names: Caspar, Melchior and Balthasar, symbolizing Asia, Europe and Africa.*

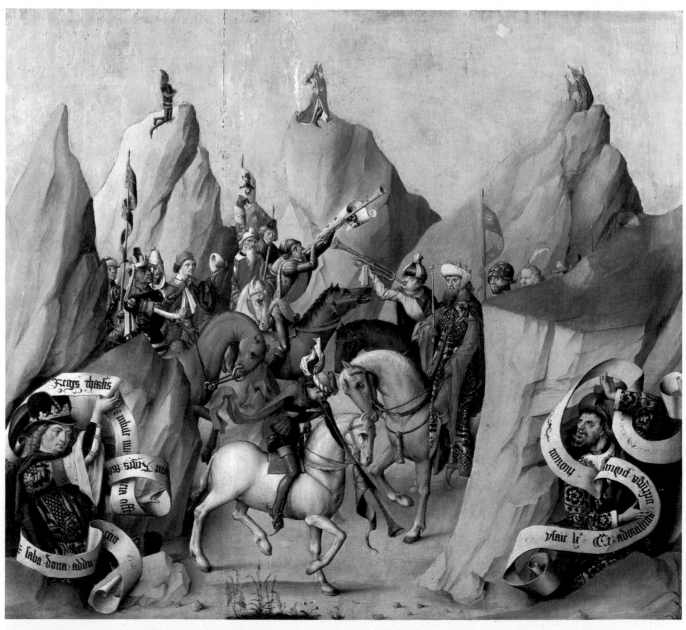

**22.** *THE JOURNEY OF THE MAGI,* BY THE MASTER OF THE ST. BARTHOLOMEW ALTARPIECE. BEFORE 1480 (?).

**23.** *THE THREE MAGI,* BY JULIUS SCHNORR VON CAROLSFELD. 1819. DETAIL OF PLATE 20.

When they had heard the king, they departed; and, lo, the star, which they saw in the east, went before them, till it came and stood over where the young child was. When they saw the star, they rejoiced with exceeding great joy.

◀ *This detail reveals the passion Schnorr von Carolsfeld developed for the trappings of medieval life. Like his Pre-Raphaelite contemporaries in England, the artist and his like-minded colleagues – known as Nazarenes – wished to break with tradition and establish a more romantic style, which they linked with the supposed simplicity of the Middle Ages.*

▶ *A star and baby in combination signal the presence of the Christ in Bethlehem to the Three Kings, whose clothes are shown in intricate detail. The star – here a symbol of the birth – has been linked to a conjunction of planets or the appearance of a comet; but such attempts at an explanation do not bear close analysis.*

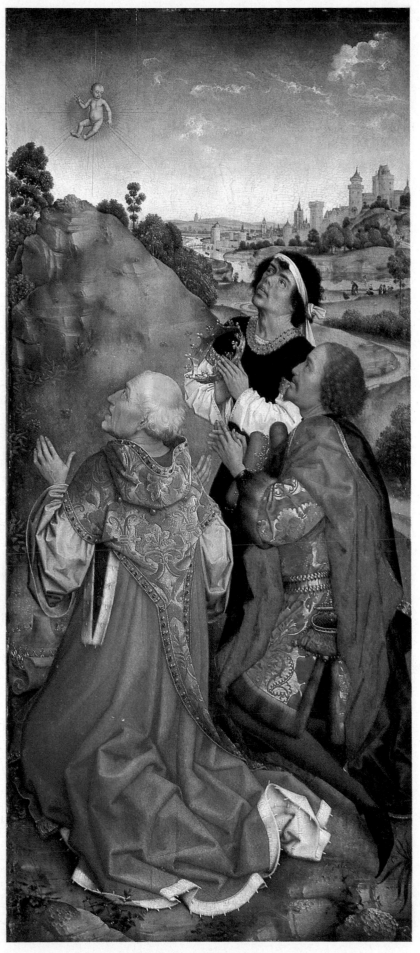

**24.** *THE STAR OF BETHLEHEM APPEARING TO THE MAGI,* BY ROGIER VAN DER WEYDEN. ABOUT 1450.

# 4: Adoration

*In a masterpiece of detail — narrative, social, religious and human — the Kings see the star (top left), proceed in cavalcade to Bethlehem and clatter pell-mell down to the stable, where in the words of one critic, they fall "like stills from a stroboscopic film, into attitudes of deepening adoration." In the calm of the stable, the Baby, in a gesture combining benediction and childish exploration, blesses a King. One foot is extended to be kissed; the other curls away from the ticklish beard.*

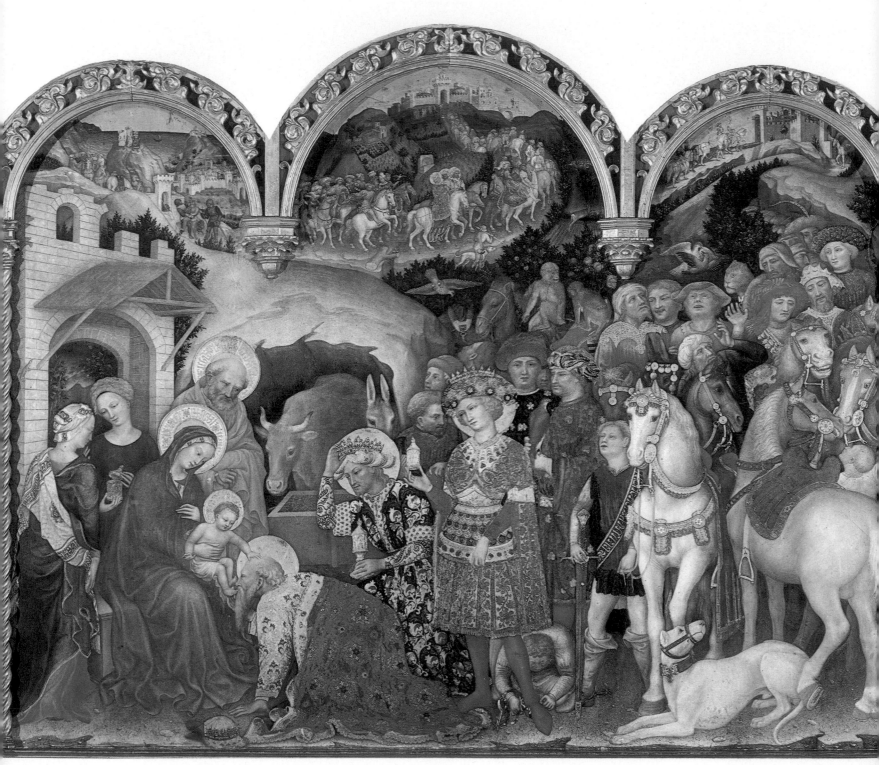

**25.** *THE ADORATION OF THE MAGI,* BY GENTILE DA FABRIANO. 1423.

*Though no more than an underpainting for a work Leonardo never completed, this is a masterpiece of imagination. Like Gentile, he includes a crowd; but here the figures are part of the outside world, not of the Adoration scene. Horses prance, people cavort and pose. It is as if Leonardo wished to symbolize the significance of the event for all mankind. The Virgin's serenity is emphasized by the simplicity of the central design – a triangle that has its apex in her head.*

**A**nd when they were come into the house, they saw the young child. . . .

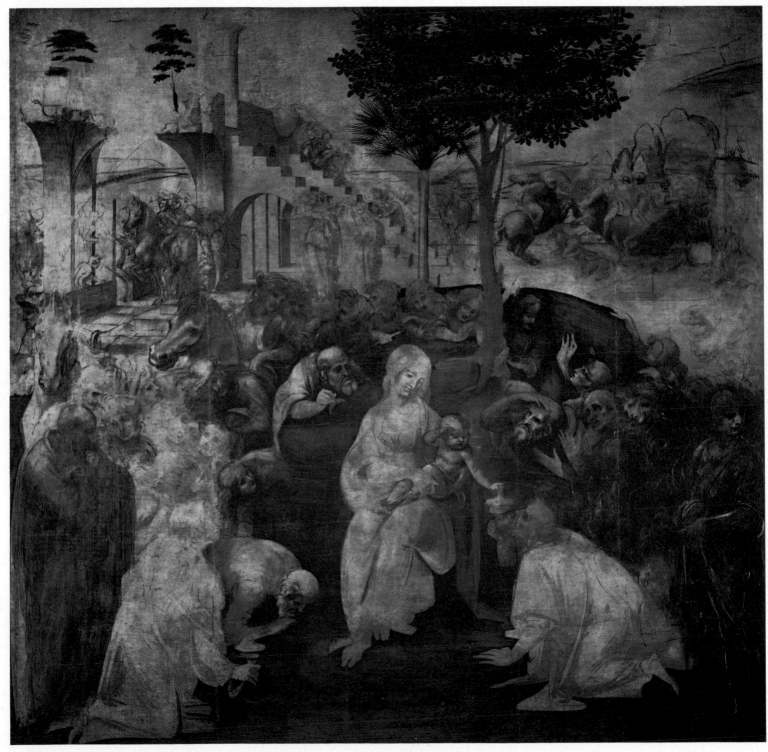

**26.** *THE ADORATION OF THE MAGI,* BY LEONARDO DA VINCI. ABOUT 1481.

**W**ith Mary his mother, and fell down, and worshipped him: and when they had opened their treasures. . . .

▼ As if seen through a wide-angle lens, the Holy Family, serene and calm, is bracketed by the Kings' retinues and a matching crowd of onlookers on the walls (right). The peacock on the stable roof was a symbol of Christ's immortality.

▶ Rubens' Adoration reflects the qualities of the man himself: full of startling energy, delighting in colour and movement, of many talents and passions, including a dedication to Catholicism, which inspired his many religious works.

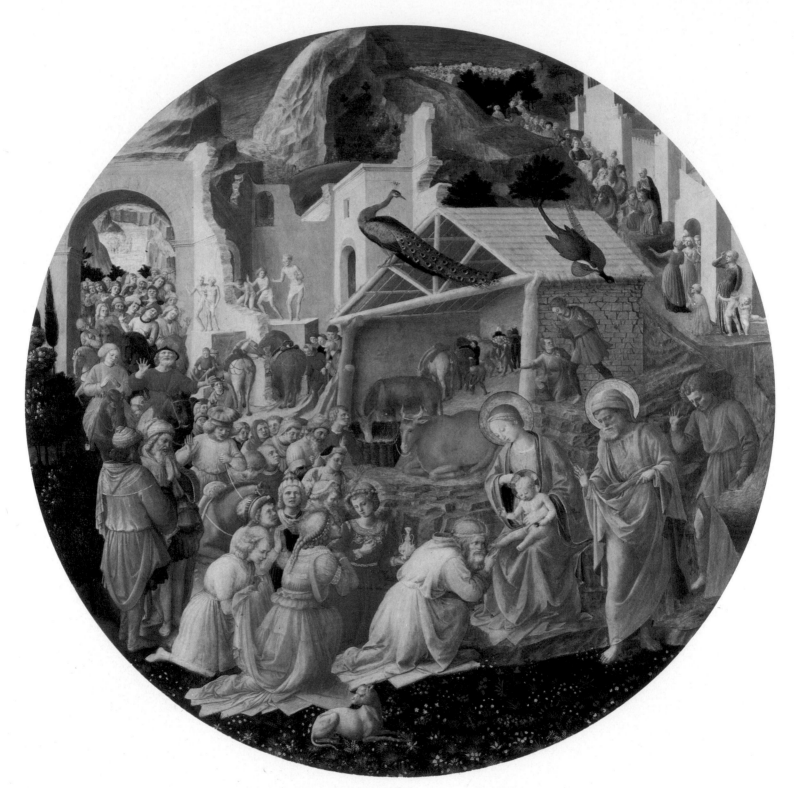

**27.** *THE ADORATION OF THE MAGI*, BY FRA ANGELICO. MID-15TH CENTURY.

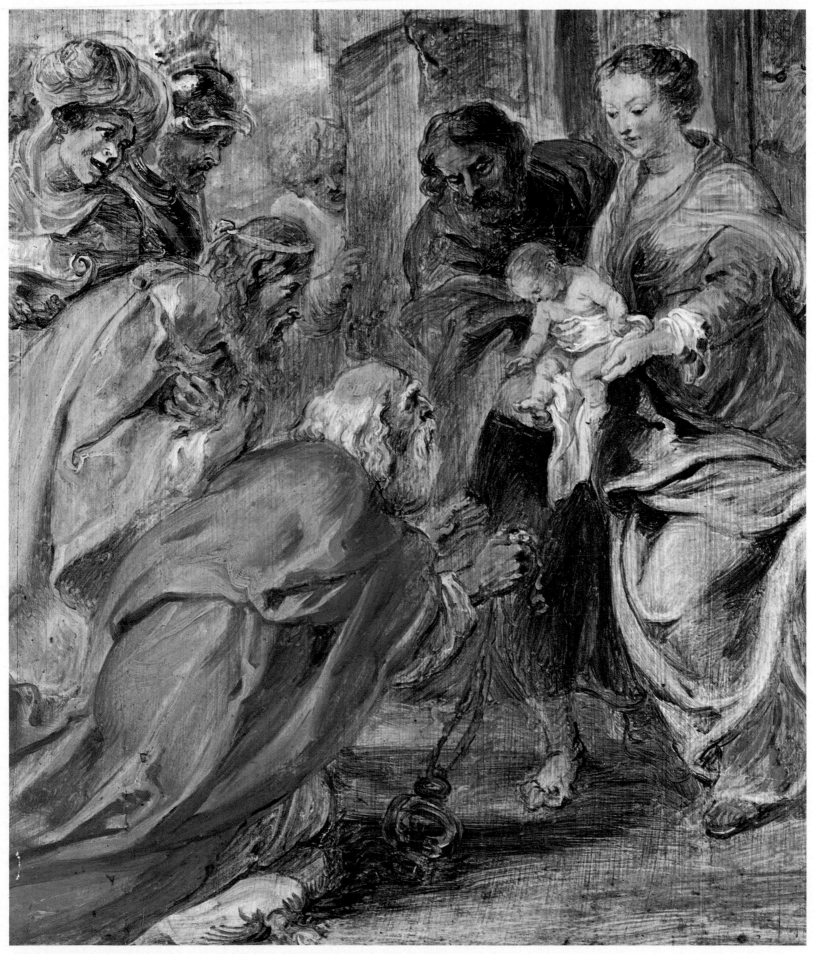

**28.** *THE ADORATION OF THE MAGI* (DETAIL), BY SIR PETER PAUL RUBENS. 1633–4.

They presented unto him gifts; gold, and frankincense, and myrrh. And being warned of God in a dream that they should not return to Herod, they departed into their own country another way.

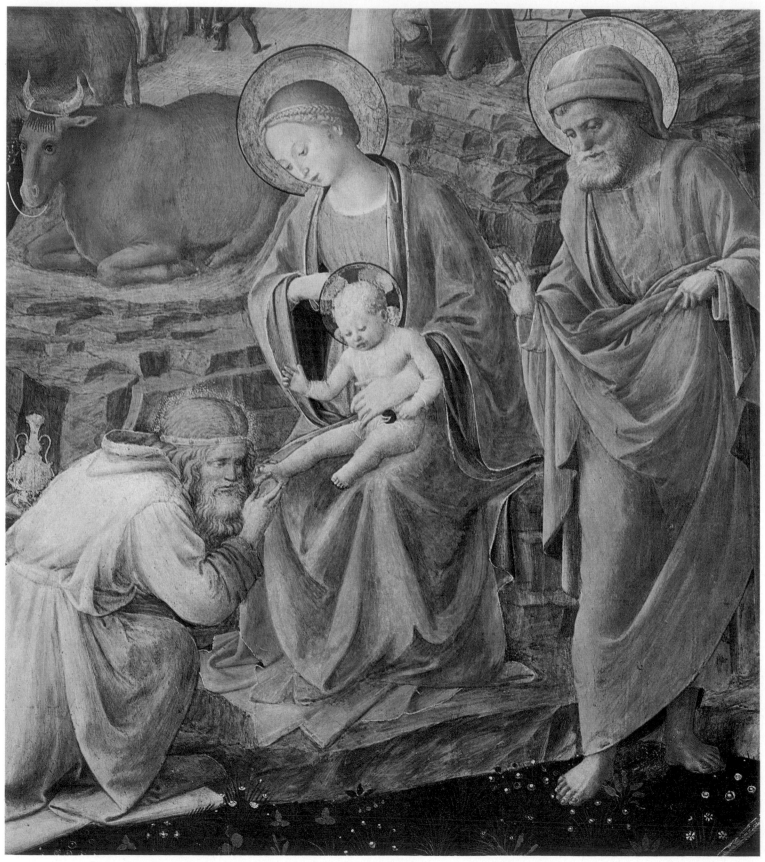

**29.** *VIRGIN, CHILD AND KING,* BY FRA ANGELICO. MID-15TH CENTURY. DETAIL OF PLATE 27.

And they [the shepherds] came with haste and found Mary, and Joseph, and the babe lying in a manger.

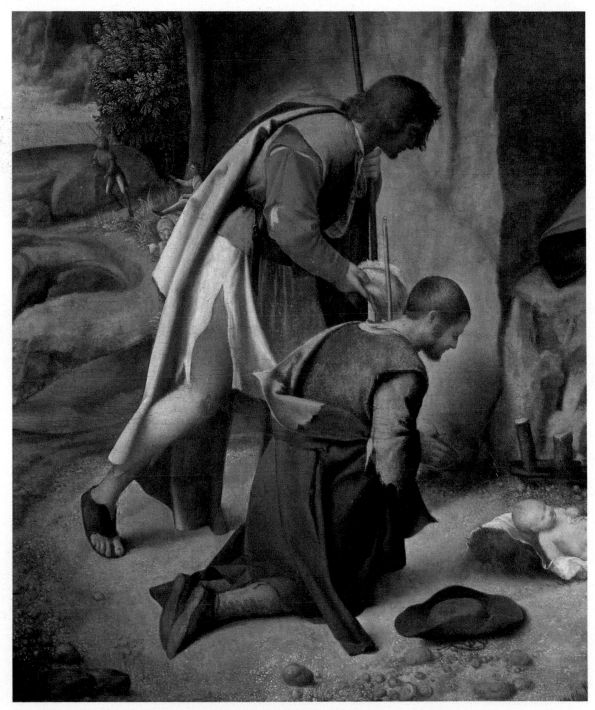

◀ *A King greets the newborn Babe, attended by the ox and ass, the animals traditionally associated with the Nativity in accordance with Isaiah's prophecy: "The ox knoweth its owner and the ass its master's crib."*

▶ *Though chronologically the shepherds – shown here in tatters worshipping the Christ Child – arrived well before the Wise Men, the two acts of adoration are set together here to contrast the shepherds' poverty with the Kings' riches.*

**30.** *THE ADORATION OF THE SHEPHERDS* (DETAIL), BY GIORGIONE. 1505–10.

A nd when they had seen it, they
made known abroad the saying
which was told them concerning
this child.

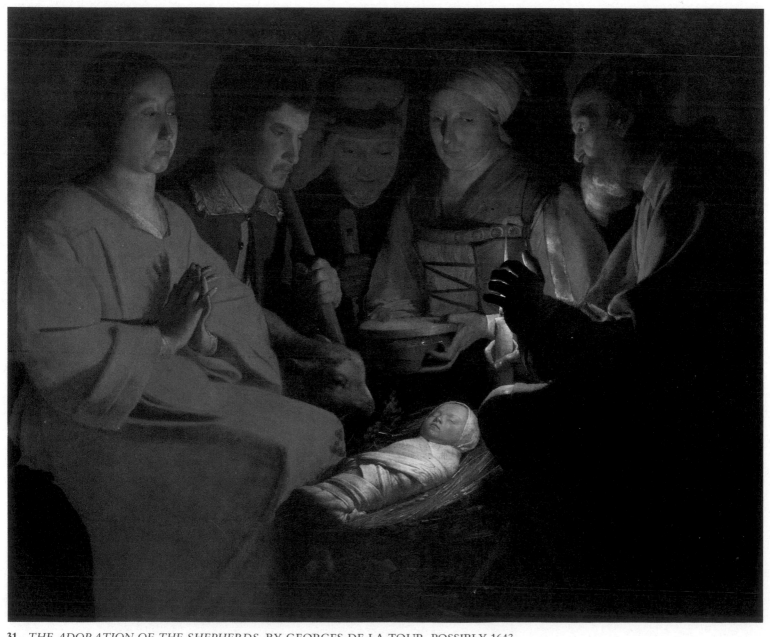

**31.** *THE ADORATION OF THE SHEPHERDS,* BY GEORGES DE LA TOUR. POSSIBLY 1643.

◀ *La Tour's mastery of candle-light allows him to focus the viewer's attention on a solemn scene – a swaddled Baby watched silently by simple people. A smirking peasant boy in the background touches his cap, as if to a passing bigwig, unable, perhaps, to understand the implications of what he sees.*

▶ *A marked contrast to La Tour's work, El Greco's painting is a mystical creation, its light apparently coming directly from the Child himself. The scene exists in its own immaterial space, in which angels float freely, bearing their Christmas banner.*

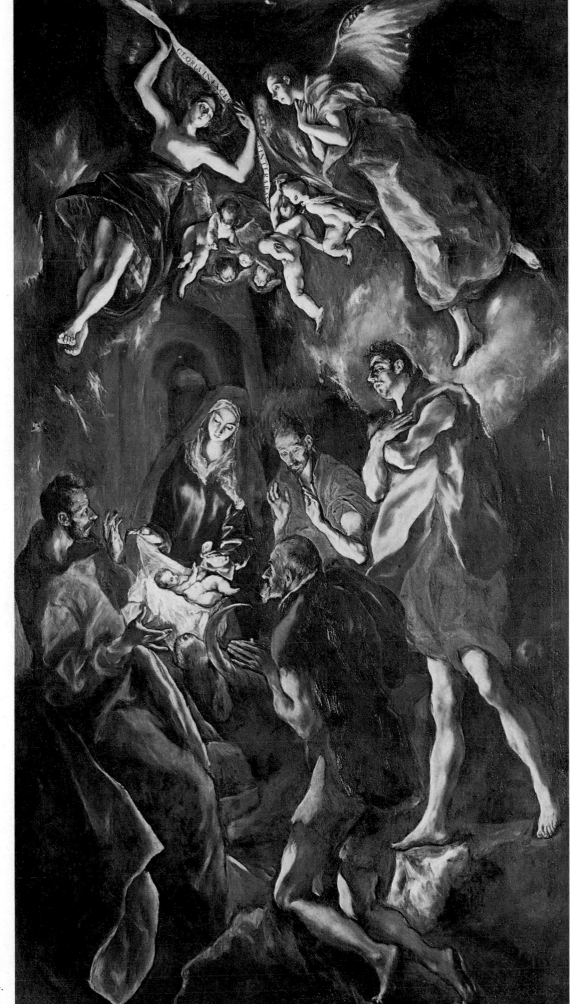

**32.** *THE ADORATION OF THE SHEPHERDS*, BY EL GRECO. 1612–14.

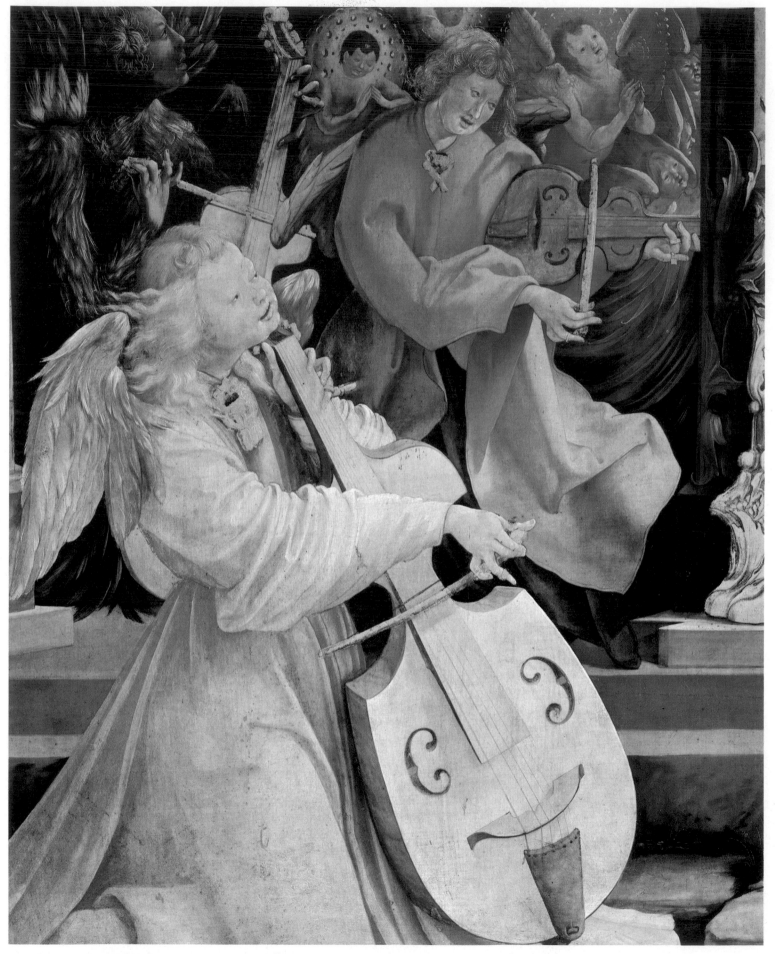

**33.** *ANGELS MAKING MUSIC,* BY MATHIS GRÜNEWALD. ABOUT 1513–16. DETAIL OF PLATE 35.

◄ *A heavy-jowled angel, with an inadequate pair of wings, scrapes out celebratory music on a bass viol.*

▼ *This close up of La Tour's Baby shows a charming touch – a lamb nosing forward to sniff the new arrival.*

And all they that heard it wondered at those things which were told them by the shepherds. But Mary kept all these things, and pondered them in her heart.

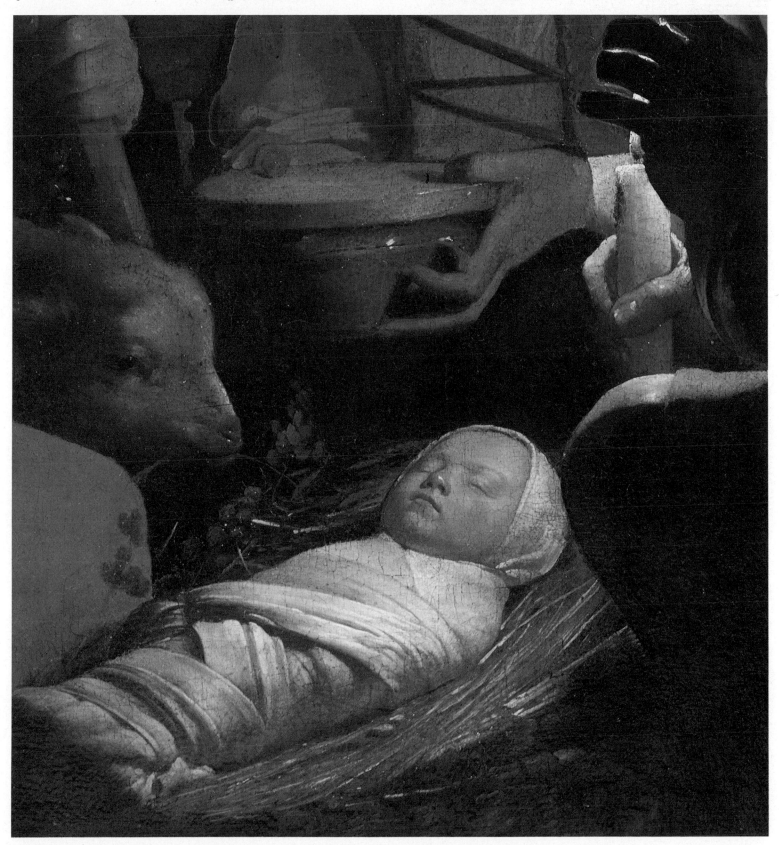

**34.** *VIRGIN AND CHILD, BY GEORGES DE LA TOUR. POSSIBLY 1643. DETAIL OF PLATE 31.*

# 5 : The Holy Family

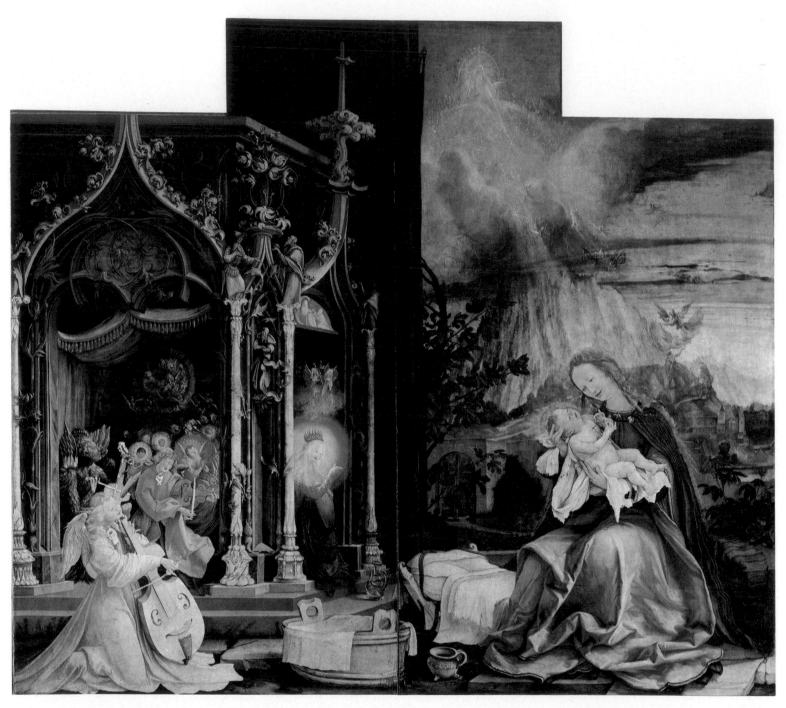

**35.** *THE VIRGIN AND CHILD WITH ANGELS MAKING MUSIC*, BY MATHIS GRÜNEWALD. ABOUT 1513–16.

▲ *In this altar painting done for the Abbey of Isenheim, Alsace, Mary sits among a peasant's domestic objects, a strange contrast to the ornate chapel and the angels that sing and whirl above like scattered petals. One critic has written that the Child seems "a sturdy Swabian peasant, with snub nose, sharp eyes, and a pink smiling face."*

▶ *Although angels rejoice and satanic imps flee into the earth at the coming of Christ, the joy in Botticelli's painting seems restrained. In fact, the artist was near despair at the martyrdom of the reformer Savonarola, burned at the stake in 1498, whose death Botticelli considered truly apocalyptic (as the inscription implies, see the Notes on the plates).*

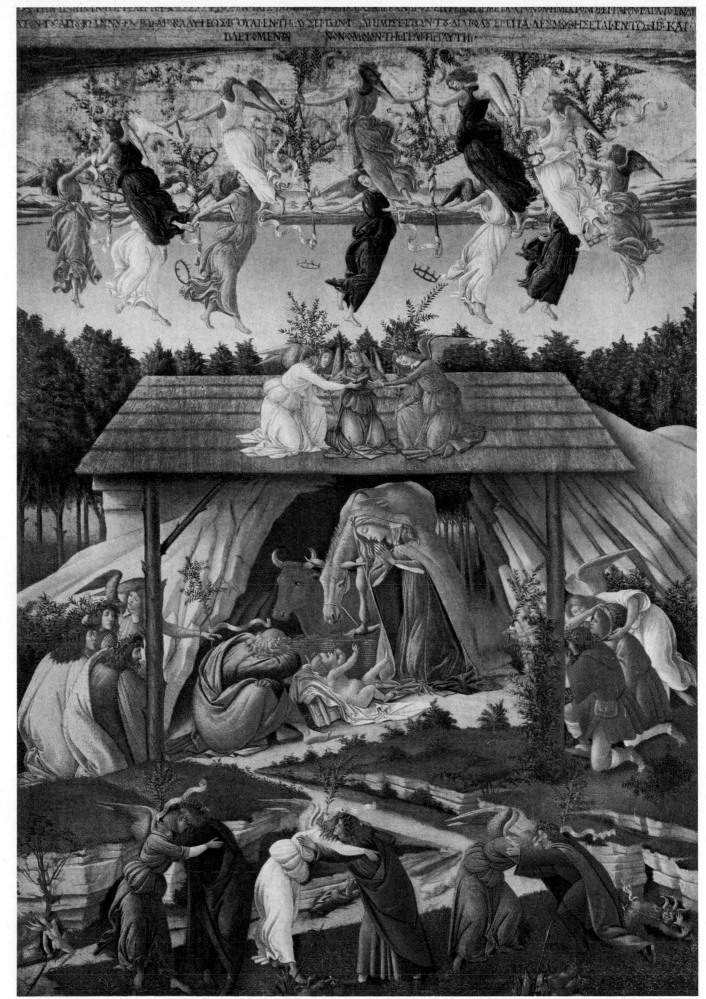

**36.** *THE MYSTIC NATIVITY, BY SANDRO BOTTICELLI.* 1500 (?).

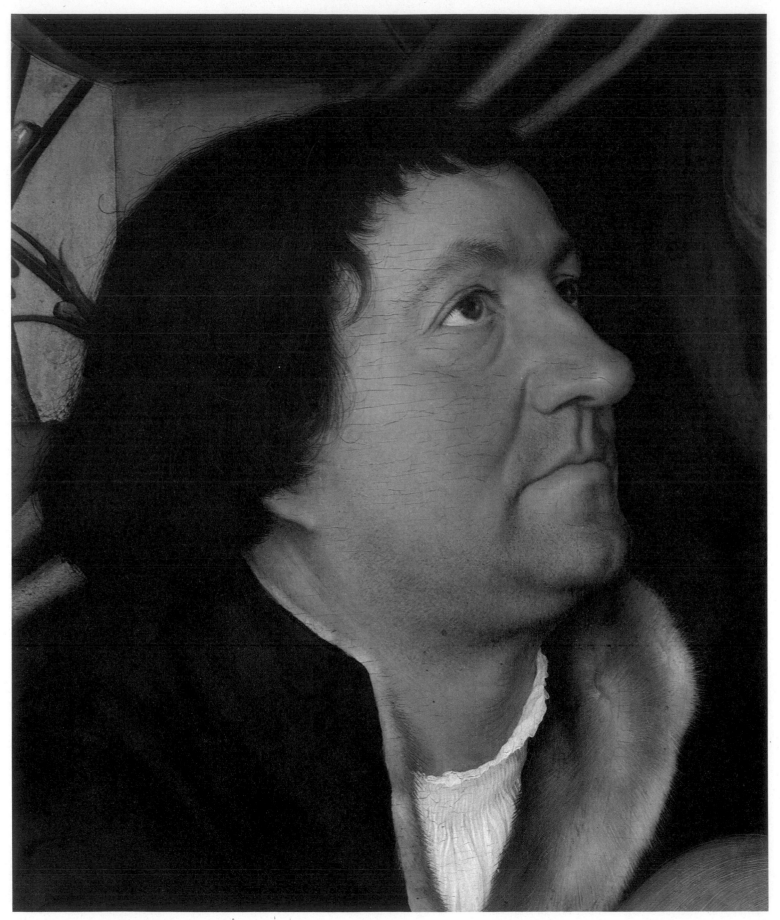

**37.** *JAKOB MEYER.* DETAIL OF PLATE 38.

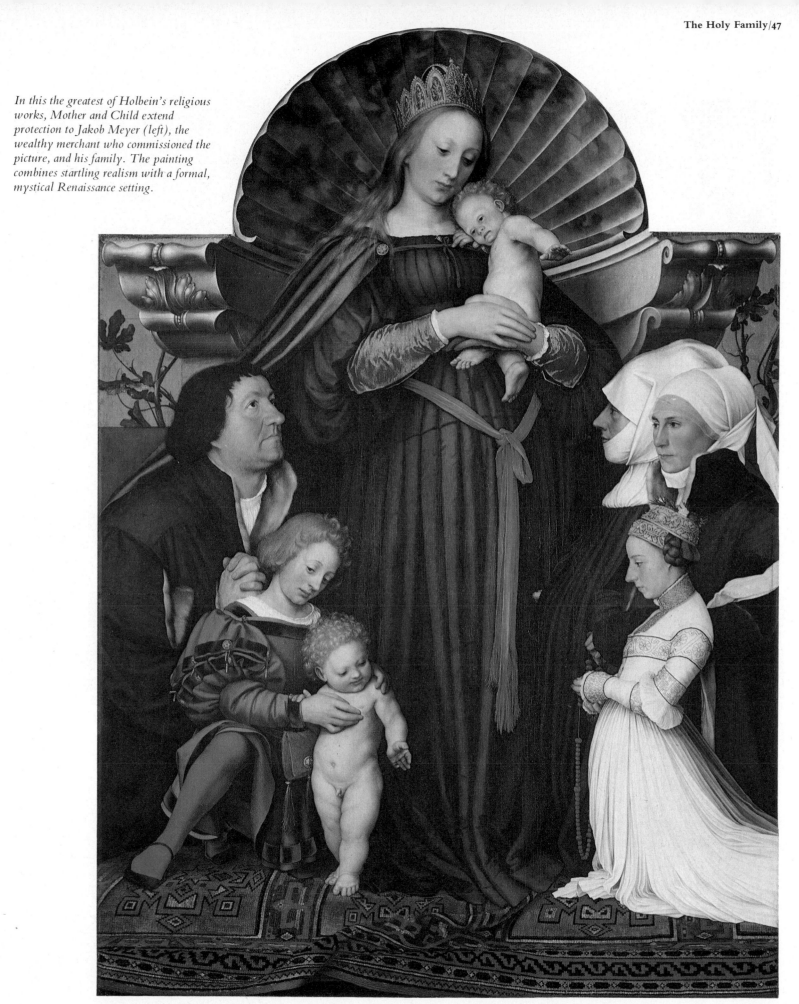

*In this the greatest of Holbein's religious works, Mother and Child extend protection to Jakob Meyer (left), the wealthy merchant who commissioned the picture, and his family. The painting combines startling realism with a formal, mystical Renaissance setting.*

**38.** *THE VIRGIN AND CHILD WORSHIPPED BY THE MEYER FAMILY,* BY HANS HOLBEIN THE YOUNGER. 1528–30 (?).

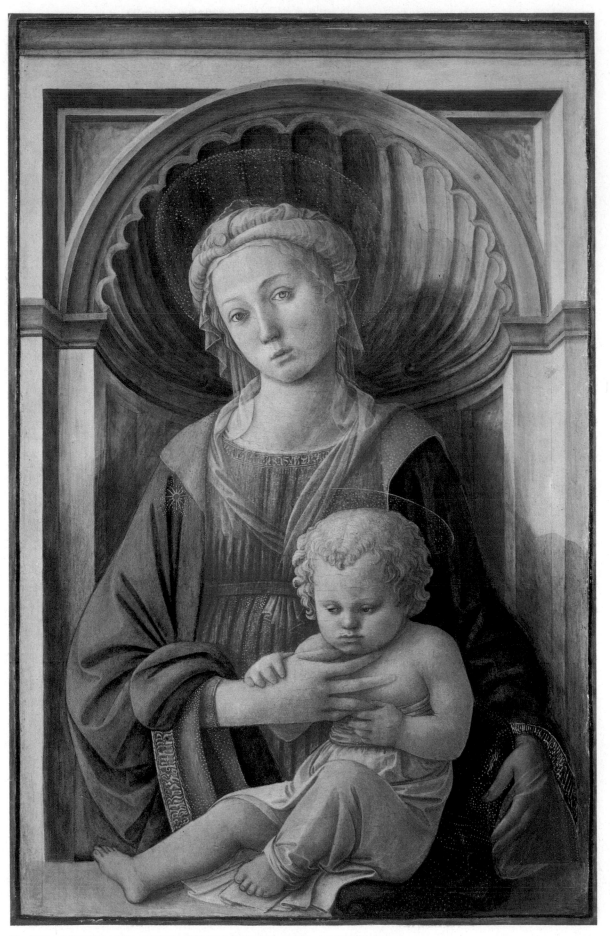

*These two pictures, done some 400 years apart, have a remarkable similarity of mood: a purity of line, a serenity, an intimacy, which in the Lippi (left) derives from the Mother's soulful glance and the Child's moody pout; and in the von Carolsfield (right), from the tender contact between the couple.*

**39.** *THE VIRGIN AND CHILD,* BY FRA FILIPPO LIPPI. ABOUT 1440–45.

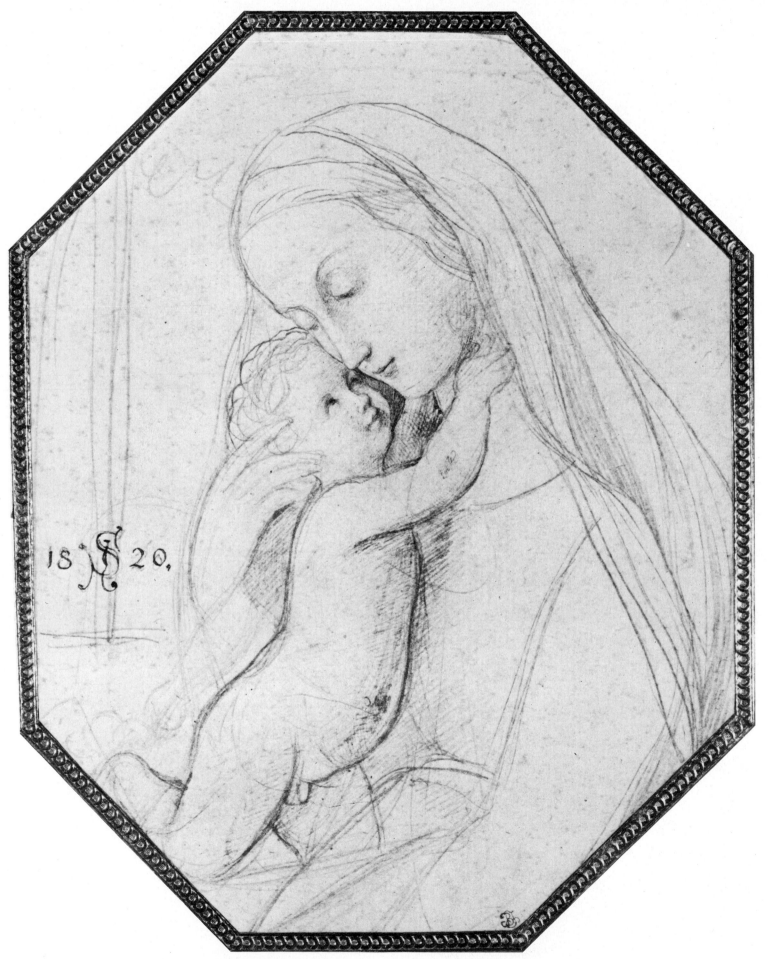

**40.** *THE VIRGIN AND CHILD, BY JULIUS SCHNORR VON CAROLSFELD. 1820.*

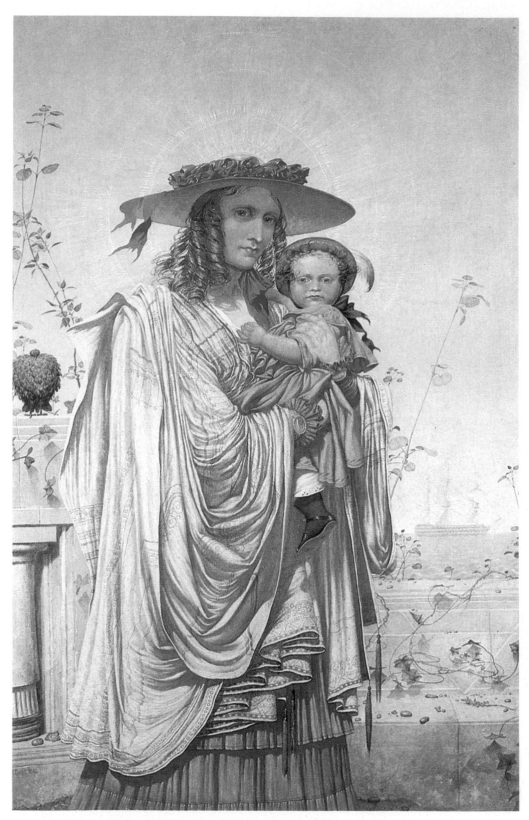

**41.** *THE VIRGIN AND CHILD, BY RICHARD DADD. 1860.*

▶ *In the mysterious solitude of a fantastic rocky shelter that rises like a natural cathedral, the Christ Child, held by an angel, blesses the young John the Baptist, who kneels in adoration. The painting exists in two versions; Leonardo took some twenty years to complete the pair.*

◀ *Dadd – mystical, imaginative and in later life insane – has here created an enigma. The work has a religious purity, and the pose is classic, but the only real religious touch is the sun-beam halo. The odd details – like the puffed-up bird and the man-o'-war – are typical of the artist.*

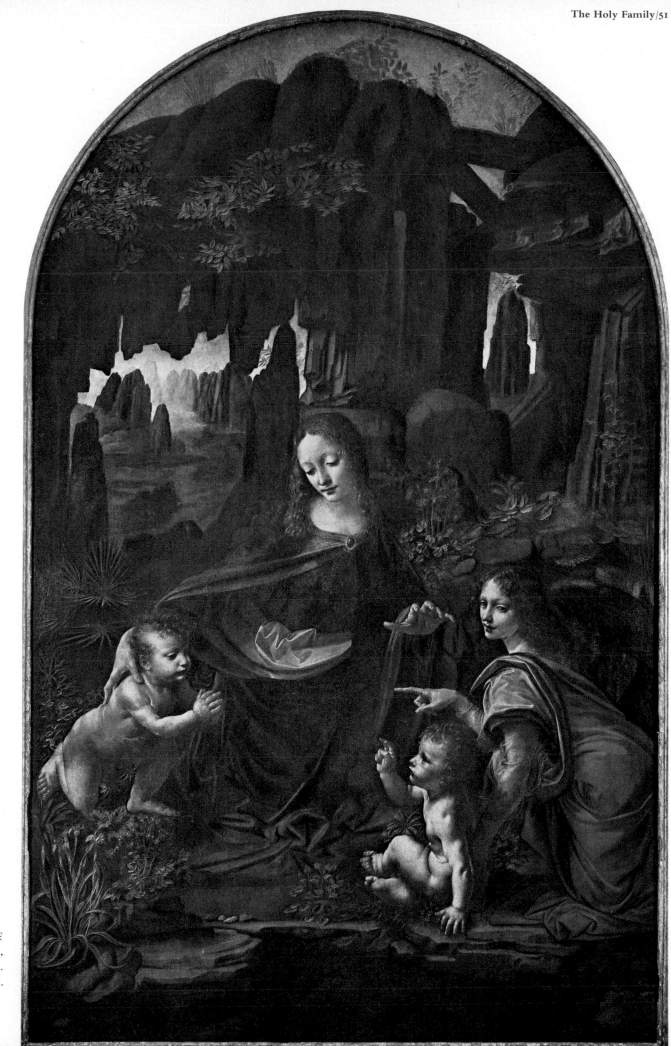

**42.** *THE VIRGIN OF THE ROCKS,*
*BY LEONARDO DA VINCI.*
*ABOUT 1481–2.*

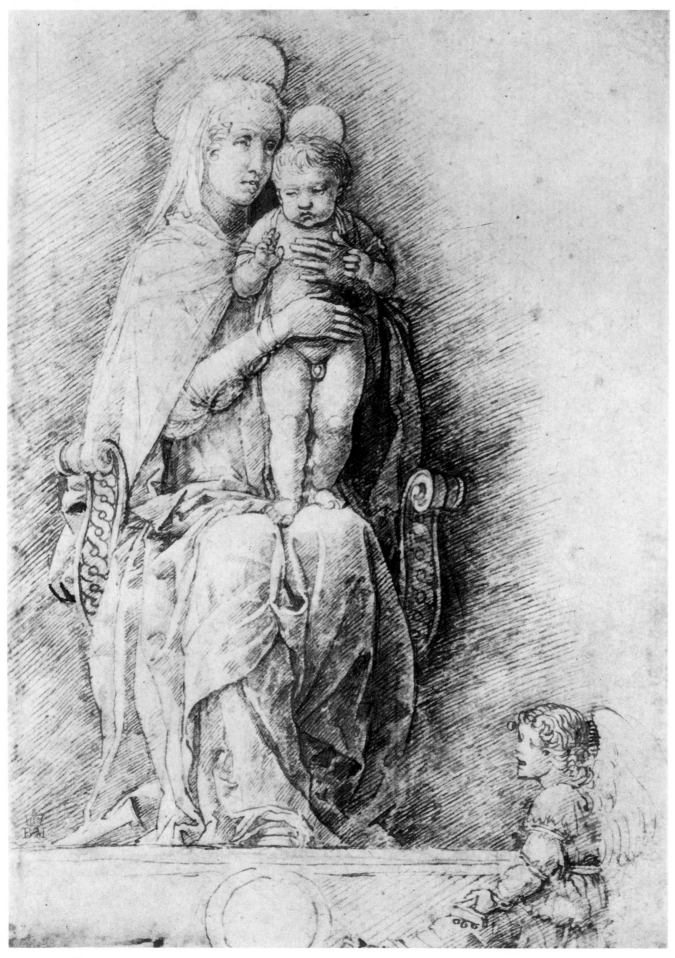

**43.** *THE MADONNA AND CHILD ENTHRONED* BY ANDREA MANTEGNA. PERHAPS 1490–95.

And when eight days were accomplished for the circumcising of the child, his name was called JESUS, which was so named by the angel before he was conceived in the womb.

◀ *The Virgin seated on an elaborate throne such as might have decorated a 15th-century Italian palace, holds the Christ Child, his hand raised in blessing.*

▼ *In a formal religious setting, the young Child is circumcised. Although part of Jewis Law, circumcision was abandoned by the Church in the 1st century.*

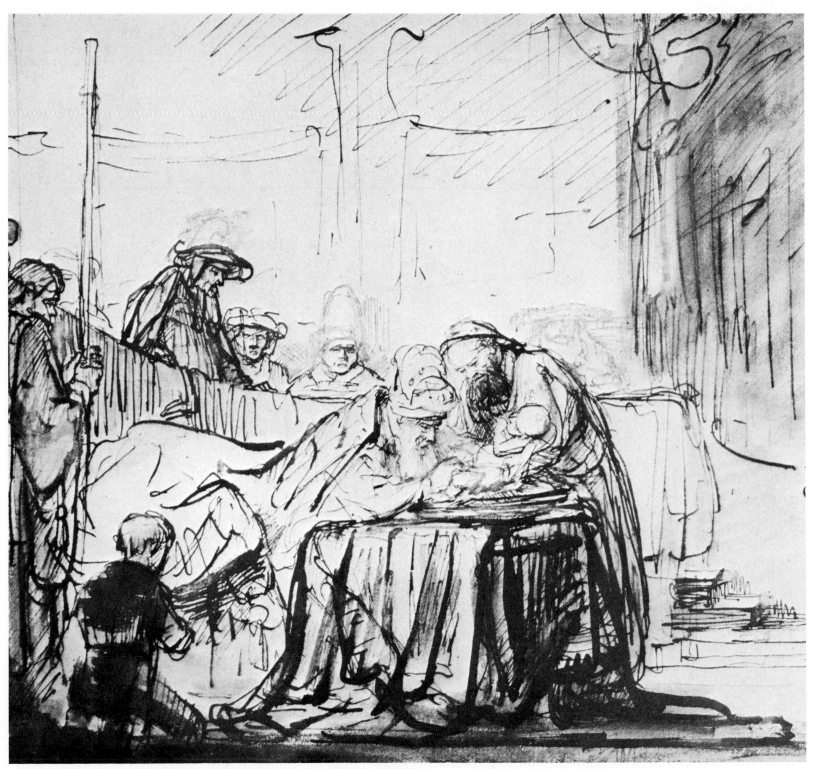

**44.** *THE CIRCUMCISION (DETAIL), BY REMBRANDT. ABOUT 1645–6.*

And when the days of her purification according to the law of Moses were accomplished, they brought him to Jerusalem, to present him to the Lord; . . . And, behold, there was a man in Jerusalem, whose name was Simeon; and the same man was just and devout, waiting for the consolation of Israel: and the Holy Ghost was upon him. And it was revealed unto him by the Holy Ghost that he should not see death, before he had seen the Lord's Christ. And he came by the Spirit into the temple: and when the parents brought in the child Jesus, to do for him after the custom of the law, Then took he him up in his arms, and blessed God, and said, Lord, now lettest thou thy servant depart in peace, according to thy word; For mine eyes have seen thy salvation, Which thou hast prepared before the face of all people.

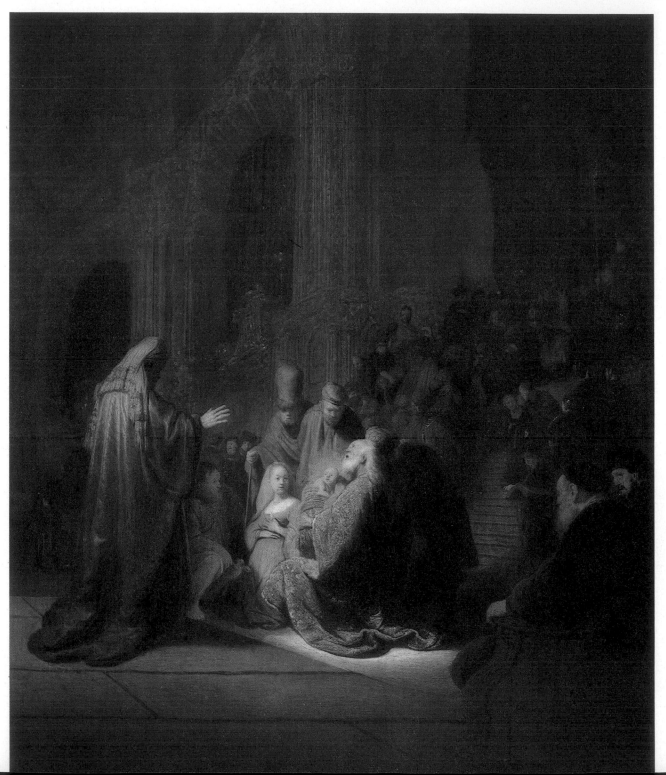

**45.** *THE PRESENTATION IN THE TEMPLE,* BY REMBRANDT. 1631.

# 6: The Flight

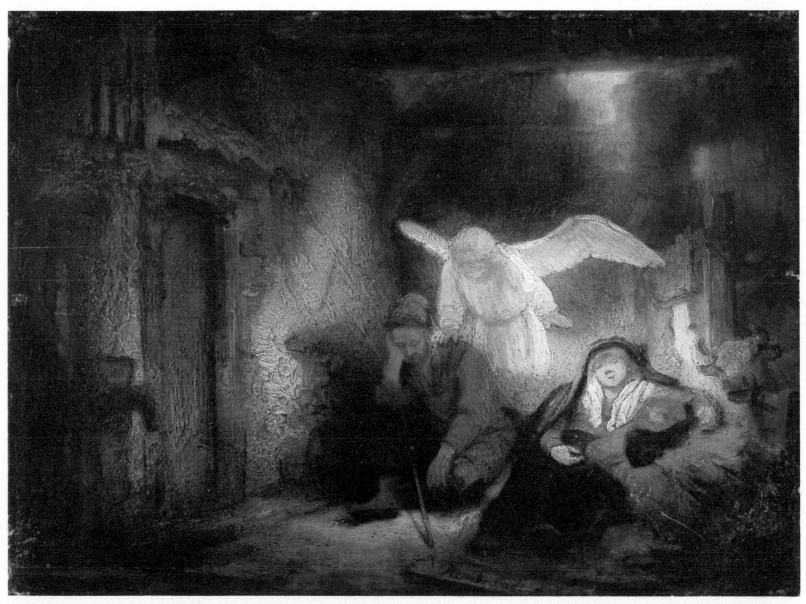

◀ *Caught in a shaft of light before the High Priest, the aged Simeon holds the Christ Child and declares himself now ready for death. Joseph holds two sacrificial doves.*

▲ *This seldom seen little picture shows the angel descending – almost as part of the moonlight that filters through the stable roof – to tell Joseph that he must take his wife and newborn baby into Egypt.*

**46.** *JOSEPH'S DREAM IN THE STABLE AT BETHLEHEM, BY REMBRANDT. 1645.*

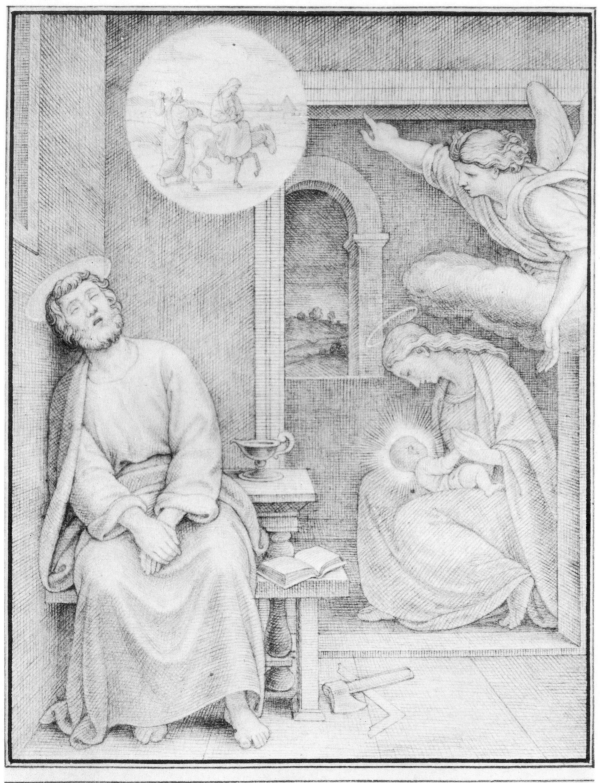

**47.** *JOSEPH'S DREAM*, BY FRIEDRICH OLIVIER. 1836.

◀ *Joseph dozes, his carpenter's tools on the floor, as a cloud-borne angel reveals God's plan, which is represented by the cartoon-like device of a vignette of the family fleeing into Egypt, identified by the presence of a pyramid.*

▶ *In a beautifully planned group that tops a pillar, Joseph leans forward, leading his wife and child on the ass through a forest. Mary apparently bears some fruit for the journey.*

And flee into Egypt, and be thou there until I bring thee word: for Herod will seek the young child to destroy him. When he arose, he took the young child and his mother by night, and departed into Egypt: And was there until the death of Herod: that it might be fulfilled which was spoken of the Lord by the prophet, saying, Out of Egypt have I called my son.

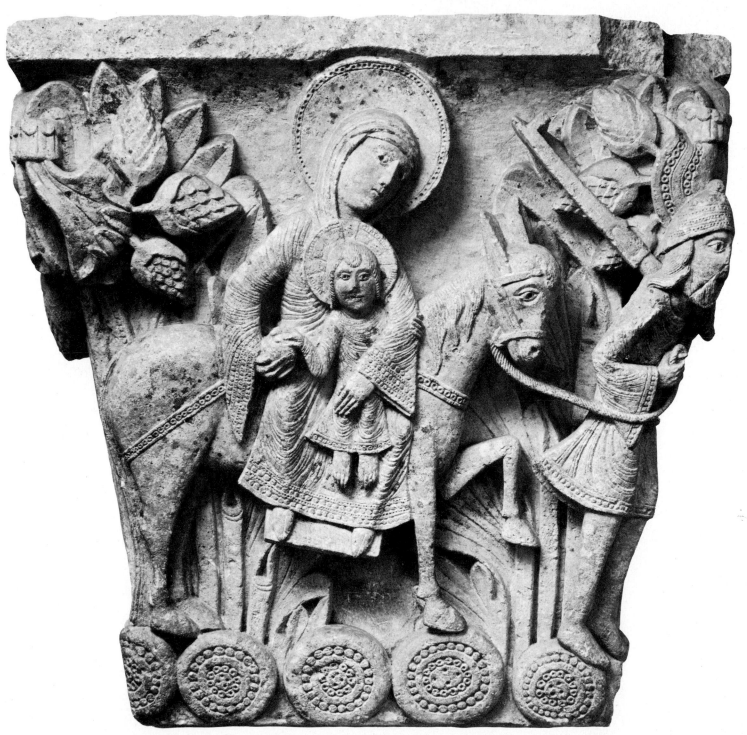

**48.** *THE FLIGHT INTO EGYPT.* STONE CAPITAL FROM AUTUN CATHEDRAL. 1120–30.

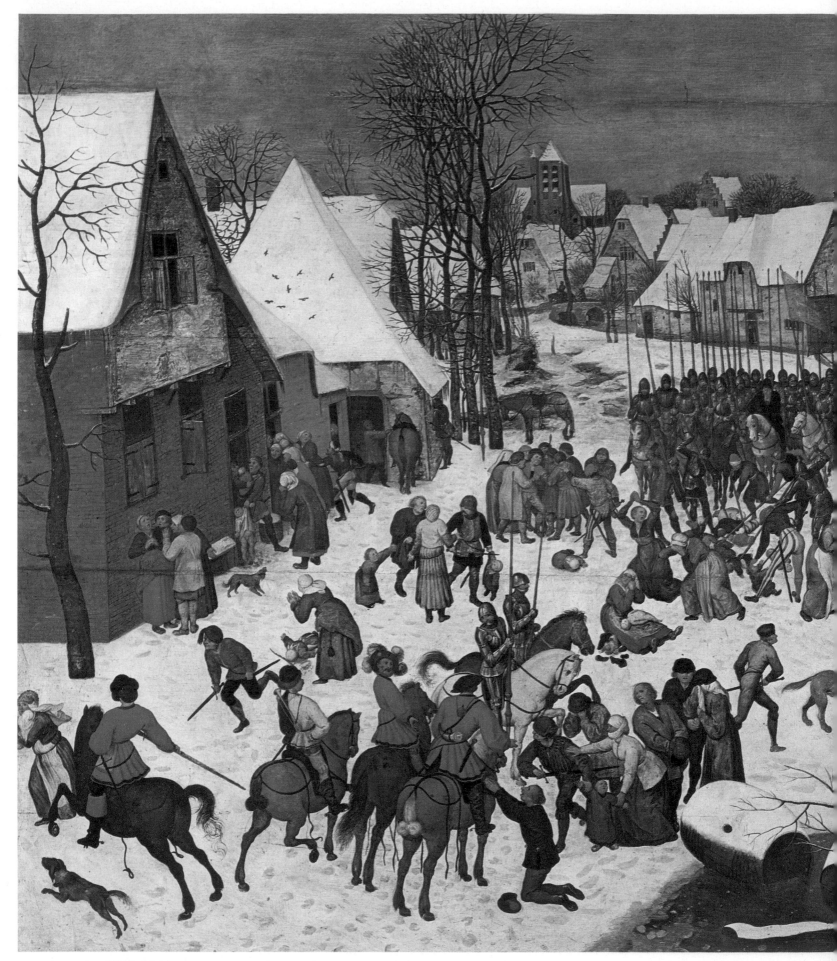

**49.** *THE MASSACRE OF THE INNOCENTS (DETAIL), BY PIETER BRUEGEL THE ELDER. ABOUT 1566.*

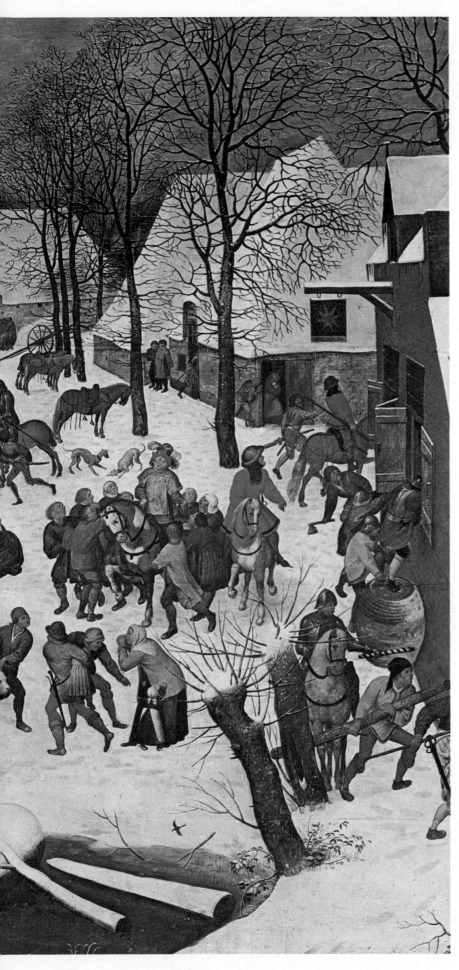

When Herod, when he saw that he was mocked of the wise men, was exceeding wroth, and sent forth, and slew all the children that were in Bethlehem, and in all the coasts thereof, from two years old and under, according to the time which he had diligently inquired of the wise men.

*Bruegel has turned Herod's attempt to snuff out the life of the newborn Christ into a marauding raid on an isolated Flemish hamlet, a reflection of Catholic Spanish repression in the Protestant Low Countries. Scholars have speculated that the black-clad horseman heading a body of troops is the merciless Spanish ruler, the Duke of Alba.*

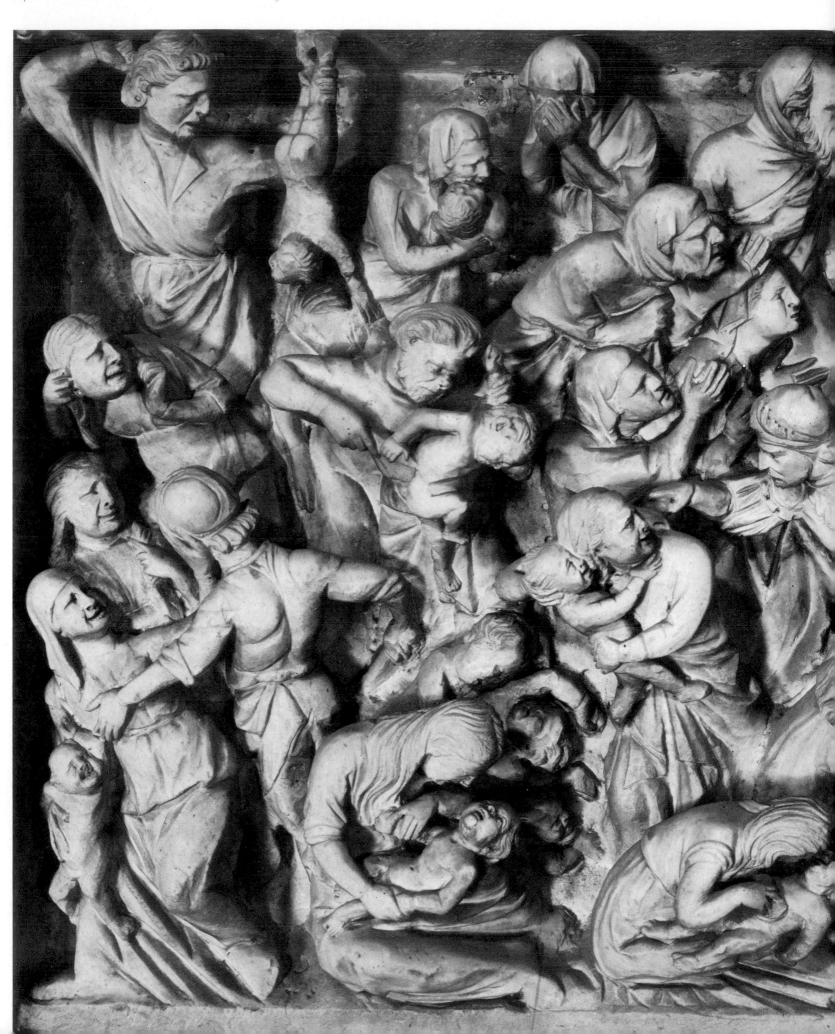

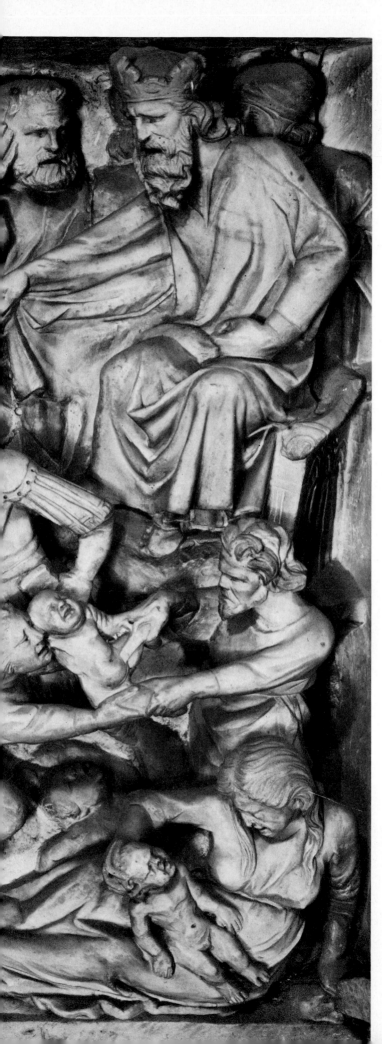

**W**hen was fulfilled that which was spoken by Jeremy the prophet, saying, In Rama was there a voice heard, lamentation, and weeping, and great mourning, Rachel weeping for her children, and would not be comforted, because they are not.

*Amidst a writhing mass of struggling bodies, mothers implore Herod (right) to spare their children, aided by protests from men who probably represent dissenting advisers (top centre).*

**50.** *THE MASSACRE OF THE INNOCENTS,* BY GIOVANNI PISANO. 1301.

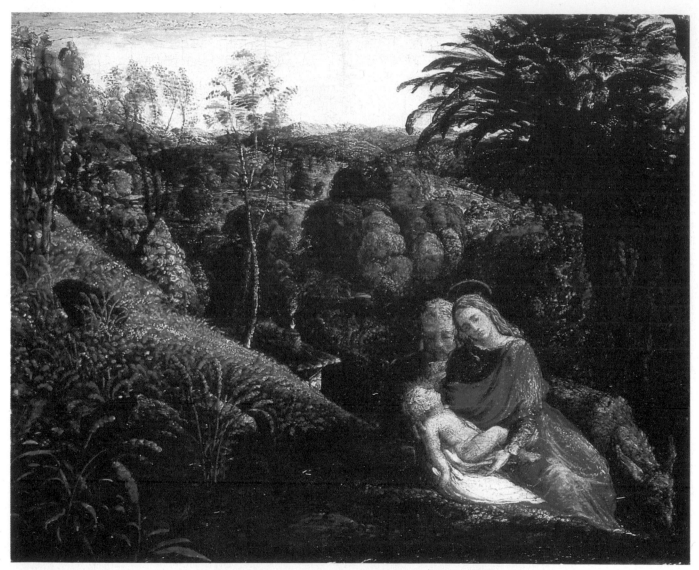

**51.** *THE REST ON THE FLIGHT INTO EGYPT,* BY SAMUEL PALMER. ABOUT 1824–5.

*Both these pictures reveal the artists' deep passion for nature. Palmer was intensely involved with the Kentish countryside, while Runge was one of the main German Romantic painters.*

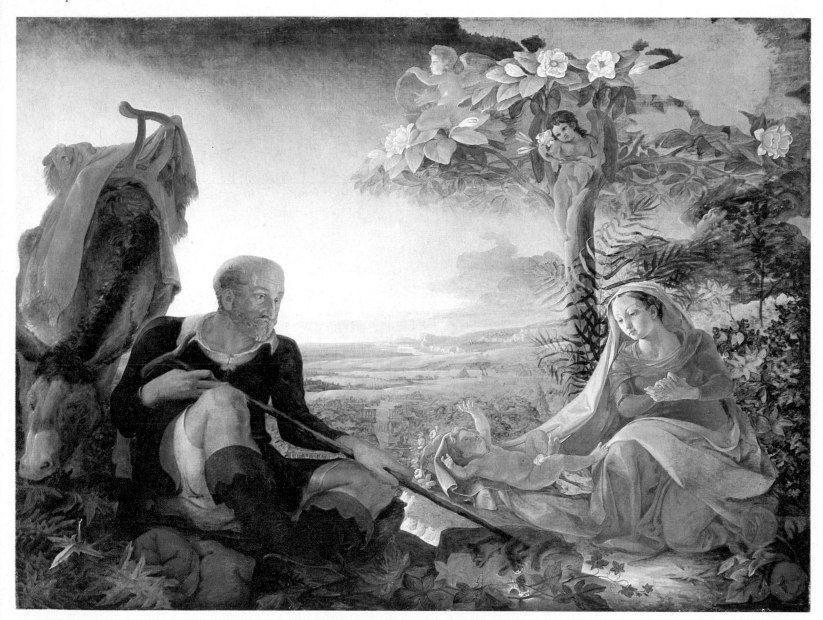

**52.** *THE REST ON THE FLIGHT INTO EGYPT,* BY PHILIPP OTTO RUNGE. ABOUT 1805.

But when Herod was dead, behold,
an angel of the Lord appeareth in a
dream to Joseph in Egypt,
Saying, Arise, and take the young child
and his mother, and go into the land of
Israel: for they are dead which sought the
young child's life.

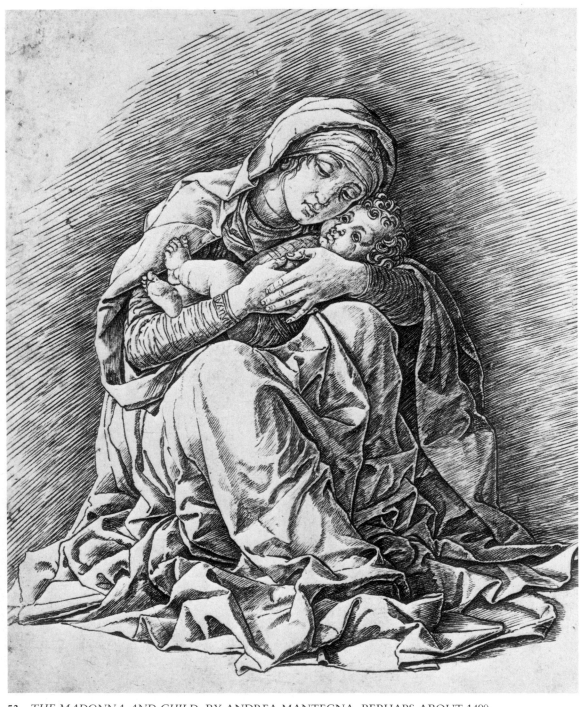

**53.** *THE MADONNA AND CHILD*, BY ANDREA MANTEGNA. PERHAPS ABOUT 1490.

# Notes on the plates

*Introduction*

There are no contemporary works that illustrate the New Testament. And the text itself is epic and generalized in style; it 'states' rather than 'describes' a person or a place. There is no Biblical description of what Jesus Christ looked like. But as the Christian Faith spread, and strengthened its hold on the mind and imagination in societies where a large proportion of the population was illiterate, the demand for cult images grew. To provide such ever-present reminders of the Faith, artists drew as much on their own experiences, skills, imaginations and artistic traditions as on the Bible itself.

One might suppose that the limited amount of information in the New Testament would have given artists a corresponding freedom to invent scenes and the appearance of sacred characters as they wished. However, as the Faith developed, it was supported by an increasing number of rules that became almost as fixed as Holy Writ. It became traditional to show the Virgin Mary, for example, in a reddish dress covered by a dark – almost invariably blue – mantle; and this is how she appears in paintings by Fra Angelico (Plate 27); Gentile de Fabriano (Plate 25); Grünewald (Plate 35); El Greco (Plate 32); and Runge (Plate 52). At the same time, as long as artists *did* follow the basic rules, they were often free to add all manner of subsidiary details of their own. Hence the extraordinary variety and vitality of religious art from the seventh to the nineteenth century.

This was not only due to individual differences in character; previous ages had differing attitudes towards the past. Nowadays, in the history of religion, art or thought, even fiction, we emphasize historical reality. In past centuries, this was not so. Although archaeology flourished, especially in Italy with its wealth of ancient Roman remains, artists did not necessarily seek, nor were they even asked to achieve, historical accuracy in their renderings of Biblical stories. The very fact that religion was a pervasive, everyday part of life and society only encouraged artist and spectator alike to see the Life of Jesus Christ in contemporary terms, in 'modern dress'. The medieval Miracle Plays, after all, were not 'correct', carefully researched reconstructions by paid professionals but lively dramatic impersonations involving a whole community. A faith that is strong can afford to reinterpret fundamentals in its own terms; it can afford humour.

The religious art of the past, as I hope this anthology shows, was brimming with life and humour, curiosity and invention. Often it was at the forefront of achievement. It is likely that the most sophisticated creation of Western society in the early 1480s was not the equivalent of a breakthrough in medicine or space-exploration but a painting: Leonardo da Vinci's enchanting *Virgin of the Rocks* (Plate 42).

Keith Roberts

# Notes on the plates

**1.** *Angels making music. Detail of Plate 5.*

**2.** *The Annunciation* by Federico Barocci (c. 1535–1612). Etching, 44 × 31·2 cm. Somerville & Simpson Ltd., London.

Barocci was one of the most important Italian painters active in the last thirty years of the sixteenth century. This is one of four known etchings by him and is after a large altarpiece that he painted in 1582–4 (now in the Vatican, Rome).

**3.** *The Virgin of the Annunciation* by Jacopo Carucci, called Pontormo (the name of the Tuscan village where he was born) (1494–1557). Red chalk drawing, 39·3 × 21·7 cm. Uffizi, Florence.

Pontormo was among the most important of the early Mannerist painters in Italy. He is celebrated for his religious frescoes, altarpieces and portraits. This is a study for the figure of the Virgin Mary in the fresco painted about 1527 on the window wall of a small chapel in the Florentine church of Santa Felicità. The Virgin is on the right of the window, the hovering angel on the left. The ruled squares on the drawing were made to help the artist transfer the design to the wall.

**4.** *The Annunciation* by Jacquemart de Hesdin (died c. 1411) and his assistants. Page from the illuminated manuscript known as the *Très Belles Heures de Jean de Berry*.

The manuscript was acquired by Jean, Duc de Berry (1340–1416), before 1402 and shortly afterwards given to the Duke of Burgundy. It is now in the Royal Library in Brussels. 'Belles Heures' (beautiful hours) refers to a 'Book of Hours', a type of devotional work intended to inspire religious contemplation and often decorated with illuminated miniatures of important religious subjects.

**5.** *The Annunciation* by El Greco (1541–1614). Canvas, 315 × 174 cm. 1596–1600. Villanueva y Geltrú (Spain), Museo Balaguer.

El Greco, one of the greatest of Spanish painters, was actually born in Crete and his real name was Domenicos Théotocopoulos; 'El Greco' is Spanish for 'The Greek'. He specialized in religious subjects, which he treated in a highly personal way, with elongated figures, unusual lighting and glowing colour. This picture, together with an *Adoration of the Shepherds* (Bucharest) and a *Baptism of Christ* (Madrid),

originally formed part of the high altar of the Augustinian Colegio de Doña María de Aragón in Madrid.

**6 & 7.** Details of the Angel and the Virgin Mary from *The Annunciation* by Donatello (c. 1386–1466). Limestone (with gilding), 420 × 248 cm. About 1428–33. Church of Santa Croce, Florence.

Donatello was the greatest of fifteenth-century Italian sculptors; he specialized in religious subjects, many of which were produced for the churches of his native Florence. His art was to be extremely influential on the course not only of sculpture but also of painting. The beautiful heads in this *Annunciation* are reminiscent of ancient Roman statues, which were admired in the fifteenth century for their mixture of realism and grace.

**8.** *'Ecce Ancilla Domini'* (The Annunciation) by Dante Gabriel Rossetti (1828–82). Canvas mounted on panel, 72·6 × 41·9 cm. Initialled and dated March, 1850. Tate Gallery, London.

D. G. Rossetti, poet as well as painter, was one of the founder member of the Pre-Raphaelite Brotherhood, created in 1848 to combat the tawdriness of contemporary art. The group, which also included Millais and Holman Hunt, wanted to recover the freshness and innocence they felt had existed in painting in the period before the High Renaissance (Pre-Raphaelite = before Raphael). Rossetti's picture has the directness, simplicity and other worldliness of the best Pre-Raphaelite works.

**9.** *The Visitation* by Jacopo Carucci, called Pontormo (1494–1557). Panel, 202 × 154 cm. About 1528–30. Pieve di S. Michele, Carmignano, near Florence.

This important altarpiece shows many of the same characteristics as *The Annunciation* (Plate 3): the same elongation of the body and the same facial type.

**10.** Studies for *The Visitation* (detail) by Sir Peter Paul Rubens (1577–1640). Pen, ink and wash, 26·25 × 36 cm. About 1612–13. Musée Bonnat, Bayonne.

These lively studies show Rubens, the great master of the exuberant Baroque style, experimenting with poses and gestures for the large oil-painting that he made of the subject. This is in fact on the left wing (or shutter) of the altarpiece of *The Descent from the Cross* now in Antwerp Cathedral, one of the works that helped to establish his reputation in the

Catholic and Spanish-dominated Netherlands, where he became the leading religious painter of the age.

**11.** *The Virgin of the Annunciation* by Michelangelo (1475–1564). Black chalk, 34·8 × 22·4 cm. About 1545–7. British Museum, London.

Michelangelo's supreme reputation rests on his sculpture and the paintings on the ceiling of the Sistine Chapel; but he was also a superlative draughtsman, recognized as such by contemporaries. Occasionally he would help fellow artists by providing preparatory drawings for their own paintings. That is the case here: Michelangelo's drawing has been connected with two altarpieces of *The Annunciation* by Marcello Venusti (active 1548; died not before 1579) in churches in Rome.

**12.** *The Numbering at Bethlehem* (detail) by Pieter Bruegel the Elder (c. 1525–69). Panel, 116 × 164·5 cm. Signed and dated 1566. Musées Royaux des Beaux-Arts, Brussels.

One of the greatest works by the most important sixteenth-century Flemish painter. The coming of the Holy Family to Bethlehem, and their arrival at the inn, had often been depicted before in Flemish art but the numbering or taxing is not usual before Bruegel.

**13.** *Studies for a Virgin and Child* by Raphael (1483–1520). Pen and brown ink over preliminary indications in metal-point, 11·4 × 13 cm. About 1502–4. Ashmolean Museum, Oxford.

Raphael, one of the great masters of the Italian High Renaissance, is famous for his small devotional paintings that feature the Virgin and the Baby Jesus, sometimes with an infant St. John the Baptist or Joseph. These 'Madonnas' are characterized by great sweetness of expression, tenderness of mood and beauty of design; and none of these qualities were achieved without careful thought and preparation. This particular study is one of several for a *Virgin and Child* now in an American Private Collection and shows Raphael working out the relationship between the figures and the background, which he sketches again in the upper right corner of the sheet.

**14.** *Study for a Figure of the Infant Christ* ascribed to Giovanni Bellini (c. 1425/30–1516). Brush drawing, washed and heightened with body colour, 20·6 × 28·5 cm. Perhaps 1480–90. Ashmolean Museum, Oxford.

The authorship of this very fine drawing presents a difficult art historical problem. It is a study for the Infant Christ in a devotional picture of the type that Raphael also painted (see Plate 13 and note).

**15.** *The Holy Family Asleep with Angels* by Rembrandt (1606–69). Pen and ink, 17·5 × 21·3 cm. About 1645. Fitzwilliam Museum, Cambridge (Louis C. G. Clarke Bequest).

The tenderness, immediacy, power and variety of Rembrandt's illustrations to the Bible have never been surpassed. One of the loveliest, this simple sketch shows the Holy Family asleep; and they are treated in wholly contemporary terms.

**16.** Angels making music. Detail of Plate 35.

**17.** *The Angel Appearing to the Shepherds* by Rembrandt (1606–69). Etching, 26·2 × 21·9 cm. Signed and dated 1634. Ashmolean Museum, Oxford.

Rembrandt was as equally great a master of etching as of drawing and painting. This print belongs to his exuberant Baroque period when he was most interested in movement and drama – note the physical reaction to the sudden apparition not only of one of the shepherds but also of the animals, which scatter in fright. The fondness for strong contrasts of light and shade (for which the technical term is *chiaroscuro*) was one of the constants of Rembrandt's art.

**18.** *The Nativity* by Piero della Francesca (1410/20–92). Panel, 124·5 × 123 cm. Perhaps about 1470–5. National Gallery, London.

It is only in the present century that Piero della Francesca has come to be recognized as one of the greatest of Italian artists; and *The Nativity* is among his most lyrical creations. The type of defenceless Babe and the detailed landscape were influenced by Flemish painting, which was beginning to be admired in Italy in the 1460s and 1470s.

**19.** Detail of *The New-Born Child* by Georges de La Tour (1593–1652). Canvas, 76 × 91 cm. About 1646–8. Musée des Beaux-Arts, Rennes.

Georges de La Tour, whose total known output was only some forty paintings, has been properly rediscovered only in the present century; the stillness and purity of his vision, with its haunting light effects, has come to be appreciated almost as much as the comparable art of Vermeer. *The New-Born Child* is an unusual treatment of the Nativity. There is no visible

setting, no obvious indication that the Mother and Child are Holy Persons; and the scene is lit by a simple candle held by the attendant who sits at the left but is not included in this reproduction.

**20.** *The Procession of the Three Magi* by Julius Schnorr von Carolsfeld (1794–1872). Pencil and wash, 50 × 65 cm. Signed and dated 24 December, 1819. Museum der Bildenden Künste, Leipzig.

The German painter, Schnorr von Carolsfeld, was a member of the Nazarenes, a group active chiefly in Rome in the early nineteenth century and pledged to reform painting, rather like the Pre-Raphaelites (see Plate 8), who were influenced by them. Schnorr von Carolsfeld had a very successful career, which culminated in 1860 with the publication of a highly popular *Bible in Pictures*, for which he had made 240 drawings over a period of years. The creation of *The Procession of the Three Magi* has been admirably described by Keith Andrews (*The Nazarenes*, 1964, p. 112): 'The idea for this work originated, according to Schnorr himself, from his friend Quandt, after they had walked one day in the old gardens of Rome. Both felt an uncanny "medieval" atmosphere envelop them. "We saw noble figures of long ago move along the sombre lanes of oak-trees. In the laurel-bushes we saw lovers, we heard the sound of the lute on the terrace in front of the window of the beloved. We saw the traitor watch by the fountain whose splashing drowned his footsteps". Quandt suggested a representation of this era, and Schnorr set to work on this Christmas drawing, in which history and reality mingle. But the atmosphere implied for him immediately a New Testament background. . . . The three Magi, by following the star as the higher revelation, are searching for the true salvation. On the right, at the back, are the Foolish Virgins engaged in frivolous activities, whilst in front the Wise Virgins do works of charity by feeding and clothing the poor and performing useful duties. On the left is the highway, alongside which flows the river Jordan, pouring in the distance into the ocean. Various people walk along its path, "the way of life", and at the wayside preaches John the Baptist. In the foreground one notices a pilgrim and a woman, who bear the features of Quandt and his wife.'

**21.** Detail of *The Journey of the Magi* by Benozzo Gozzoli (c. 1421–97). Fresco. 1459–61. Palazzo Medici-Riccardi, Florence.

This is a particularly vivid example of the way in which artists have seen Biblical stories in contemporary terms. The fresco covers one of three walls which Gozzoli painted in the private chapel of the Medici family, the richest businessmen in Florence; the four horsemen in the left foreground are actually portraits of members of the family.

**22.** *The Journey of the Magi* by The Master of the St. Bartholomew Altarpiece (active late fifteenth/early sixteenth century). Panel, 61·6 × 69·8 cm. Probably before c. 1480. Private Collection, England.

This panel, which is part of the wing (or shutter) of an altarpiece, shows the three Magi twice. In the background, they kneel on top of the small mountains, looking up at the sky, where the star of Bethlehem was painted – but the top of the panel has been mutilated. They are shown again, in the main part of the picture, on their way to Bethlehem, accompanied by their attendants. The two figures hold scrolls reinforcing with Biblical quotations the events that the altarpiece was designed to illustrate. The figure at the bottom left corner is King David and his scroll, quoting *Psalms* in Latin, reads: 'The kings of Tarshish and of the isles shall bring presents: the kings of Sheba and Seba shall offer gifts.' The scroll if Isaiah, quoting *Isaiah*, reads: 'All they that despised thee shall bow themselves down at the soles of thy feet.' Both passages come of course from the *Old Testament*, which was combed by theologians for parallels and anticipations of the *New Testament*. The name of the painter is unknown; he is always called after his most famous work.

**23.** *The Three Magi*. Detail of Plate 20.

**24.** *The Star of Bethlehem Appearing to the Magi* by Rogier van der Weyden (c. 1399–1464). Panel, 91 × 40 cm. About 1450. Gemäldegalerie, Berlin-Dahlem.

This panel is the right wing (or shutter) of an altarpiece commissioned by Pierre Bladelin, who is shown kneeling in adoration in the central panel. In the background the three Magi are shown again, as very small figures bathing: the bath of the Magi and the display of the star as an Infant are not of course mentioned in the *New Testament* but they do occur in *The Golden Legend*, a medieval compilation of apocryphal incidents that was accepted by the Church and often inspired artists.

**25.** *The Adoration of the Magi* by Gentile da Fabriano (c. 1370–1427). Panel, 282 × 300 cm. 1423. Uffizi, Florence.

This elaborate altarpiece, of which only the main panel is shown here, is among the last and richest expressions of the Late Gothic style. 'The Adoration of the Magi', as a subject, was a perfect excuse for a display of lavishness in the clothes and accessories of the three Kings and their attendants. Gentile da Fabriano has even found room for two monkeys.

**26.** *The Adoration of the Magi* by Leonardo da Vinci (1452–1519). Underpainting in brown on panel, 246 × 243 cm. About 1481. Uffizi, Florence.

Leonardo was the greatest genius of the Renaissance, a man of unparalleled versatility. Very few paintings by him have come down to us, partly because he was usually preoccupied with other activities of a scientific and often speculative kind, but also because what really interested him was the planning and design of a painting rather than its painstaking execution. This famous *Adoration*, for example, was carried no further than the preliminary underpainting and is really a large drawing or sketch. Leonardo, like Gentile da Fabriano (Plate 25) and Fra Angelico (Plate 27), has accepted the tradition of a large crowd in attendance at the Adoration; but the subtlety and delicacy with which he has depicted their various expressions of wonder and surprise, and the care with which the composition has been built up on the basis of a triangle and a semi-circle, suggest his questioning turn of mind and impatience with merely traditional solutions to pictorial problems.

**27.** *The Adoration of the Magi* by Fra Angelico (active 1417; d. 1455) and Fra Filippo Lippi (c. 1406–1469). Panel, diameter, 137·4 cm. National Gallery of Art, Washington, D.C. (Samuel H. Kress Collection).

The authorship of this *tondo* (circular picture), which is among the most enchanting of fifteenth-century Italian paintings, is not absolutely certain; but it seems probable that the design and some of the figures (notably the Virgin and Child) are by Fra Angelico, the painting being completed after his death by Filippo Lippi.

**28.** Detail of *The Adoration of the Magi* by Sir Peter Paul Rubens (1577–1640). Panel, 50 × 36 cm. 1633–4. Wallace Collection, London.

It was quite usual in the past for artists to prepare sketches of a picture to show a client either before the contract was signed or, more often, before work on the full-scale version began. Often these sketches have a vitality and charm that is lacking in the final commission; and this is particularly true with regard to Rubens. This sketch is for the altarpiece (now in the Chapel of King's College, Cambridge) commissioned for the Convent Church of the White Sisters at Louvain. Rubens was paid 920 florins for the large-scale painting in March, 1634.

**29.** Detail of Plate 27.

**30.** Detail of *The Adoration of the Shepherds* by Giorgione (c. 1477–1510). Panel, 91 × 111 cm. 1505–10. National Gallery of Art, Washington, D.C. (Samuel H. Kress Collection).

This is one of a handful of pictures painted by one of the most mysterious of Renaissance artists, Giorgione. In the history of art, he was a kind of transitional figure, between Giovanni Bellini and Titian, and he introduced into Venetian painting a new softness, occasionally tinged with mystery, and a greater sense of mood and atmosphere. He really does set his figures *in*, rather than merely in front of, the landscape.

**31.** *The Adoration of the Shepherds* by Georges de La Tour (1593–1652). Canvas, 106·5 × 131 cm. 1643(?). Louvre, Paris.

This famous picture, which is unfortunately in bad condition, is usually associated with a commission paid for in 1644 by the town of Lunéville, where La Tour spent a large part of his life. The use of artificial light in this way reveals the influence of the Dutch followers of Caravaggio who also influenced the young Rembrandt.

**32.** *The Adoration of the Shepherds* by El Greco (1541–1614). Canvas, 320 × 180 cm. 1612–14. Prado, Madrid.

This is a very late work in the artist's final and most personal manner; it was intended for his own tomb in Santo Domingo el Antiguo, Toledo, the church for which he had produced some of his first important works after settling in Spain in the mid 1570s.

**33.** Detail of Plate 35.

**34.** Detail of Plate 31.

**35.** *The Virgin and Child with Angels Making Music* by Matthis Grünewald (1470/5–1528). Panel, approx. 265 ×

304 cm. About 1513–16. Colmar (Alsace), Unterlinden Museum.

This is the second stage, revealed when the first image of the *Crucifixion* is opened, of the altarpiece originally on the high altar of the Antonite Monastery at Isenheim. The precise meaning of all the details in this scene has never been pinned down, although the happy, celebratory character of the image is clear. The Virgin sits in the sacred walled garden (the *Hortus Conclusus*), with the church in the distance symbolizing the House of God. She is the 'rose without thorns', represented next to her on the right. It seems that the imagery of the altarpiece as a whole was partly influenced by the *Revelations of St. Bridget of Sweden*, a mystical work first published in Lübeck in 1492.

**36.** *The Mystic Nativity* by Sandro Botticelli (c. 1445–1510). Canvas, 108·5 × 75 cm. Inscribed and dated 1500(?). National Gallery, London.

This very unusual picture represents the Nativity, mostly according to the Gospel of St. Luke. Certain details are, for the date, treated in an old-fashioned way. For example, the Virgin is on a larger scale than other figures, to symbolize her importance, as in medieval art. At the top there is an inscription in Greek: 'I Sandro painted this picture at the end of the year 1500[?] in the troubles of Italy in the half time after the time according to the 11th chapter of St John in the second woe of the Apocalypse in the loosing of the devil for three and a half years then he will be chained in the 12th chapter and we shall see clearly [?] . . . as in this picture.' Unfortunately, the word indicating what we are to see clearly in the picture as been rendered illegible by damage.

**37.** Head of the Basle Burgomaster, Jacob Meyer. Detail of Plate 38.

**38.** *The Virgin and Child Worshipped by the Meyer Family* (the 'Meyer Madonna') by Hans Holbein the Younger (1497/8–1543). Limewood, 146·5 × 102 cm. Probably 1528–30. Schlossmuseum, Darmstadt.

This celebrated painting is the greatest of Holbein's religious pictures. The kneeling figures are Jacob Meyer (1482–1530/31), the Burgomaster of Basle, whom Holbein had first met in 1516, and his first as well as his second wife. The first wife, Magdalena Baer, died in 1511 and is shown in the background, her head swathed in white. His daughter, Anna, kneels on the right. On the left are Meyer's two sons.

The painting was destined for Meyer's private chapel and the perspective proves that it was intended to be seen from below. The head of Meyer is a particularly brilliant delineation of the pious donor who is so often included in altarpieces, in ages more confident and less self conscious in matters of religion than our own: it is hard to imagine, for example, a modern equivalent such as *The Virgin and Child Adored by President and Madame Pompidou*.

**39.** *The Virgin and Child* by Fra Filippo Lippi (c. 1406–69). Panel, 80 × 51 cm. About 1440–45. National Gallery of Art, Washington, D.C. (Samuel H. Kress Collection).

The painter, an orphan, was a novice at the Carmine in Florence and took the Carmelite Vows in 1421. He is first documented as a painter ten years later. This small devotional panel is characteristic of his delicate, lyrical style. The shell niche and other architectural details reveal the influence of contemporary architecture, which was much influenced by ancient Roman traditions. Note the way the haloes are carefully drawn in perspective, an optical skill that had only recently been developed.

**40.** *The Virgin and Child* by Julius Schnorr von Carolsfeld (1794–1872). Pencil, strengthened in places with pen and ink, 16·7 × 13 cm. Signed in monogram and dated 1820. Ashmolean Museum, Oxford.

A study for an oil painting now in Cologne, commissioned by the painter's friend, J. G. von Quandt, who appears in the foreground of Plate 20. This study shows particularly well the Nazarenes' concept of a purified art, stripped of the lusciousness and dramatic lighting so common in seventeenth and eighteenth-century painting. The head of the Virgin is close in mood to the work of Rogier van der Weyden (c. 1399–1464: see Plate 24), a fifteenth-century master whose purity of style was greatly admired by the Nazarenes; while the Christ Child recalls the style of the young Raphael (see Plate 13).

**41.** *The Virgin and Child* by Richard Dadd (1817–86). Canvas, 49·5 × 33 cm. Signed and dated 1860. Cecil Higgins Museum, Bedford.

This strange painting, which suggests some influence from the Nazarenes (see Plates 20 and 40), was painted by an even stranger Victorian artist. After a childhood spent in Chatham, Richard Dadd came with his family to London, where he studied at the Royal Academy. There he won two

silver medals and came into contact with Frith, Phillip, Egg and other members of what was to become known as 'The Clique', a movement of mild protest that anticipated the Pre-Raphaelites (see Plate 8). A trip to Egypt, as draughtsman to Sir Thomas Phillips, would appear to have triggered off the mental illness that was to lead, in August, 1843, to the murder by Dadd of his father. The son fled to France, was arrested, repatriated, tried, found insane and sent to the Criminal Lunatic Department of the Bethlem Hospital (the building survives, as part of the Imperial War Museum). Dadd continued to draw and paint throughout the long years of confinement in Broadmoor, where he died of consumption in 1886.

**42.** 'The Virgin of the Rocks' by Leonardo da Vinci (1452–1519). Panel, transferred to canvas, 197 × 119·5 cm. About 1481/2. Louvre, Paris.

The loveliest of Leonardo's earlier works, probably painted in Florence in or about 1482, and one of the most beautiful inventions in European painting. The Christ-Child, supported by an angel, is blessing the infant John the Baptist. The scene takes place in a rocky grotto at sunset – a visual idea without sanction in the New Testament. What makes the picture so miraculous is the way in which acute observation of the real world, evident in the flowers and plants, the structure of the rocks and details of the anatomy, is subtly transformed by the equally rigorous claims of the imagination. 'The Virgin of the Rocks' (the title is a later invention) is both visionary and naturalistic, hauntingly mysterious yet extraordinarily concrete: no one before Leonardo had described so accurately the soft, plump flesh and fine-spun hair of babies, or noticed the taut fold of flesh between the thumb and index finger (of the Virgin's hand). A later, more prosaic but better preserved version, partly by pupils but certainly worked on by Leonardo himself, is in the National Gallery, London.

**43.** The Madonna and Child Enthroned with an Angel at Her Feet by Andrea Mantegna (c. 1431–1506). Pen and ink, 19·7 × 14 cm. Perhaps about 1490–95. British Museum, London.

This enchanting sketch, which shows the infant Christ in the act of benediction, may have been made in connection with a commission for a painting, which does not survive. One of the problems that faced artists designing an altarpiece was how to create a large and imposing image without making the figures over life-size. One solution, evidently

followed here by Mantegna, was to create a throne, with steps, thus elevating the Madonna and Child, who were always the foci of the composition.

**44.** The Circumcision by Rembrandt (1606–69). Pen and wash drawing, with body colour. 20·3 × 28·7 cm. About 1645–6. Print Room, Berlin-Dahlem.

This is one of two drawings of the same subject that Rembrandt made about the same time. The second version was upright and was a sketch for a painting since destroyed. He had earlier made two etchings of the same subject.

**45.** Detail from The Presentation in the Temple by Rembrandt (1606–69). Oil on panel, 61 × 48 cm. Signed and dated 1631. Maritshuis, The Hague.

This picture, painted shortly before the artist moved from Leyden to Amsterdam and began to make a wider reputation, shows him already as a master of chiaroscuro – a technique that allowed him to make small religious works such as these so gravely moving.

**46.** Joseph's Dream in the Stable at Bethlehem by Rembrandt (1606–69). Panel, 20 × 27 cm. Signed and dated 1645. Gemäldegalerie, Berlin-Dahlem.

This small and exquisite painting, which illustrates the angel's warning that leads to the Flight into Egypt, is conceived in the same intimate, naturalistic way as the drawing of the Holy Family asleep (Plate 15), which belongs to the same moment in the artist's career. The supernatural character of the angel is suggested not by linear grace or physical perfection, as with Botticelli (Plate 36) or Leonardo (Plate 42), but by the contrast in light between the shadowy stable and the white-robed, golden-winged apparition.

**47.** Joseph's Dream by Friedrich Olivier (1791–1859). Pencil, 18·8 × 12·8 cm. 1836. Kupferstichkabinett, Berlin-Dahlem.

This interpretation of the angel's warning, the meaning clarified by the inserted vignette of the Holy Family in Egypt (identified by the pyramids), is very different from Rembrandt's (Plate 46). The treatment is not in the least naturalistic – the building could by no stretch of the imagination be called a stable – but idealized in a manner characteristic of the German Nazarenes, of whom Olivier was a member (see Plates 20 and 40).

**48.** *The Flight into Egypt.* Stone capital. 1120–30. From the Cathedral, Autun; now in the Museum.

Because we so often see works of art now in museums, it is easy to forget not only their original function but also society's attitude towards art. In the Middle Ages, a great deal of art was made for the Church, as a teaching instrument. A piece of sculpture or a painting became part of a 'Bible for the Illiterate'. All kinds of contexts were pressed into service: a religious image might appear under choir stall seats; in the roof of a church or on the bosses placed over rib joints; on doors, in porches; and, as here, on the tops (or capitals) of columns.

**49.** Detail of *The Massacre of the Innocents* by Pieter Bruegel the Elder (c. 1525–69) and Assistants. About 1566. Kunsthistorisches Museum, Vienna.

A particularly brilliant – and pointed – example of a Biblical theme interpreted in contemporary terms. Indeed, as early as 1604, the painter-historian, Carel van Mander, described in his biography of Bruegel 'a *Massacre of the Innocents*, in which we find much to look at that is true to life ... a whole family begging for the life of a peasant child which one of the murderous soldiers has seized in order to kill; the mothers are fainting in their grief, and there are other scenes all rendered convincingly.' What Van Mander does not point out, however, is that the picture may well reflect, subliminally, the contemporary political situation. Bruegel's native country, The Netherlands, was then under Spanish rule and when, in 1555, Charles V abdicated in favour of his son, Philip II, the Inquisition became more stringent than ever. The combination of political and religious persecution inevitably led to revolutionary outbreaks, notably those of 1567 under William of Orange. Reprisals were swift, especially under the infamous Duke of Alba, who was appointed Governor-General of The Netherlands in the same year. *The Massacre of the Innocents* was probably not painted with a direct political implication in mind, but there can be little doubt that for Bruegel's generation the image would have emotive overtones that are lost to us today.

**50.** *The Massacre of the Innocents* by Giovanni Pisano (c. 1248–after 1314). Marble relief, 84 × 102 cm. 1301. Church of Sant'Andrea, Pistoia.

This powerful and vivid carving is one of the panels from the side of a pulpit whose sculptural embellishment is said to have taken four years. Giovanni Pisano is the most important of Italian sculptors of the early Renaissance.

**51.** *The Rest on the Flight into Egypt* by Samuel Palmer (1805–81). Panel, 31 × 39 cm. About 1824–5. Ashmolean Museum, Oxford.

In the same way that artists dressed Biblical figures in contemporary clothes, so they set their figures in landscapes very different in character from that of the Middle East, where the events took place. This painting belongs to Palmer's famous 'Shoreham Period', when he retired to the small Kentish village and created a style of great intensity remarkable for its feeling of communion with nature. He was influenced by William Blake; and the donkey in this painting was copied from Blake's *Flight into Egypt*.

**52.** *The Rest on the Flight into Egypt* by Philipp Otto Runge (1777–1810). Canvas, 96·5 × 129·5 cm. About 1805. Kunsthalle, Hamburg.

Runge was one of the most important of the German Romantic painters; he was much interested in symbolism and colour theories, and in Nature as a source of inspiration. This painting symbolizes morning; and in a letter of 10th May 1805 he wrote of it that 'everything tends towards the central motif, of the Child in the shade playing with a sunbeam. The Child will be the most lively element of the picture and His own life will seem to be a new beginning affecting the world in front of Him.'

**53.** *The Madonna and Child* by Andrea Mantegna (c. 1431–1506). Engraving, 34·5 × 26·8 cm. About 1490(?). British Museum, London.

This grave and tender image, which was greatly admired by Rembrandt, may have been influenced by an earlier work by Donatello.